LEONARDO
THE
INVENTOR

LUDWIG H. HEYDENREICH
UNIVERSITY OF MUNICH

BERN DIBNER
DIRECTOR, BURNDY LIBRARY

LADISLAO RETI
UNIVERSITY OF CALIFORNIA

LEONARDO
THE
INVENTOR.

McGRAW-HILL BOOK COMPANY
New York St. Louis San Francisco

A McGraw-Hill
Co-Publication

Library of Congress Catalog-
ing in Publication Data
Main entry under title:
Leonardo the inventor.
 Essays originally published
in The unknown Leonardo,
edited by Ladislao Reti, with
additional illustrations.
 Includes index.
 CONTENTS:
Heydenreich, L. H.
The military architect. –
Dibner, B. Machines and
weaponry – Reti, L. The
engineer.
 1. Leonardo da Vinci,
1452–1519. 2. Leonardo da
Vinci – Knowledge –
Engineering. 3. Leonardo da
Vinci – Knowledge – Military
engineering. 4. Leonardo da
Vinci – Knowledge –
Mechanics. I. Dibner, Bern.
II. Heydenreich, Ludwig
Heinrich, 1903- III. Reti,
Ladislao. IV. Reti, Ladislao.
Unknown Leonardo.
V. Title.
T40.L46L46 620.0092'4
80-10668

ISBN 0-07-028610-8

Printed in Czechoslovakia

PERUSE ME, O READER,
IF YOU FIND DELIGHT
IN MY WORK,
SINCE THIS PROFESSION
VERY SELDOM
RETURNS TO THIS WORLD,
AND THE
PERSEVERANCE TO PURSUE IT
AND TO INVENT
SUCH THINGS ANEW
IS FOUND IN FEW PEOPLE.
AND COME MEN,
TO SEE THE WONDERS
WHICH MAY BE DISCOVERED
IN NATURE
BY SUCH STUDIES

MADRID I 6r

CONTENTS

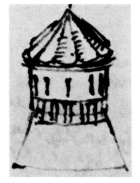

"Mechanical science
is most noble and useful above all others,
for by means of it
all animated bodies in motion
perform their operations."

INTRODUCTION

*The perspectograph – an invention of Leo-
nardo's which put mechanical skill to artistic
use – was adopted by Albrecht Dürer. With
one eye covered, the artist could trace the
outlines of a model onto a glass pane, and
thereby respect linear perspective.*

Nearly five centuries have passed since Leonardo da Vinci recorded his thoughts and designs for machines intended to simplify the routine tasks that he saw being performed around him. His purpose was to have the work done more quickly and easily, while maintaining standards of uniformity and precision. As adviser to heads of state, military commanders, nobles, and estate managers, he acted as designer, engineer, architect, geologist, anatomist, master of ordnance, and seer. Leonardo filled several notebooks with his remarkable speculations – sketches and discussions of practical and theoretical engineering problems, as well as designs for the most diverse gadgets, tools, and machines.

Two of Leonardo da Vinci's notebooks were rediscovered in 1965 in the Biblioteca Nacional, Madrid, after having been officially lost since 1830.

The two notebooks found in Madrid had been the cause of speculation in the world of letters since Leonardo's death, when many of his notebooks had become widely dispersed. By the early 18th century the two volumes known today as Codex Madrid I and II were in the palace library of Philip V of Spain, where they remained until about 1830. At that time, they were transferred to what is now the Biblioteca Nacional. Falsely catalogued, the notebooks' whereabouts remained unknown for well over a century until early 1965 when they were found in the places corresponding to their earlier correct call numbers.

McGraw-Hill and Taurus Ediciones received authorization to publish a five-volume facsimile edition of the Madrid Codices with transcription, translation, and commentary by the late Vincian scholar Ladislao Reti. On the basis of the wealth of new material in the notebooks, a group of the world's leading Vincians contributed a large-scale collection of essays, published as *The Unknown Leonardo* in 1974. This book on Leonardo the inventor, like companion volumes concerning his scientific observations and his accomplishments as an artist, is reprinted in smaller format from that voluminous work.

The first chapter by Ludwig Heydenreich on military architecture deals with the information in Codex Madrid II regarding Leonardo's plans to divert the Arno River as part of the ongoing war between Florence and Pisa, and also to fortify the town of Piombino. As Heydenreich points out, the scientific notes for the fortifications are mingled with musing on the natural beauty of this coastal town, and again the facets of Leonardo's mind can be seen at work in his notes.

The chapter by Bern Dibner on machines and weaponry is more technical in scope. Dibner discusses in detail Leonardo's ballistic concerns and sketches, such as those of the paraboloid curve of a trajectory that is deformed by air resistance, which was developed into mathematical ballistics years later by Newton. Leonardo also designed experimentally a handgun matchlock, a multiple-barrel light cannon, and even a steam cannon similar to a type used in the U.S. Civil War.

Finally, Reti's chapter on the elements of machines discusses in detail the mechanical devices of Codex Madrid I, showing that Leonardo had adopted a true scientific mode of thought: that a general principle can be derived through specific examples. This attitude is as novel as were some of the specifics Leonardo studied – screws, gears, bearings, rollers, axles – the entire range and variety of mechanics. Again, many of his sketches were years ahead of application, including a sketch for a ball-bearing design identical to one made as late as the 1920's for blind-flying instruments used in airplane navigation.

In each chapter, sketches and text re-emphasize the complexity of Leonardo's mind, his unrestrained curiosity, the congruence of art and science. The studies hint, too, at Leonardo the man – persistent, incredibly imaginative, fascinated by minute detail. The reader gains a sense of the isolation and frustration of a mind working in situations where he could receive encouragement but rarely the challenge of cooperative work with his peers. Although he worked with the brilliant leaders of his time – Verrocchio, Machiavelli, Luca Pacioli, Lodovico Sforza – none of these were fully his peer, and in the end he was alone with his curiosity.

On some levels, one can only speculate about Leonardo, "the most relentlessly curious man in history," as Kenneth Clark describes him. The more one learns, the more one desires to learn and the more challenging Leonardo's mystery becomes.

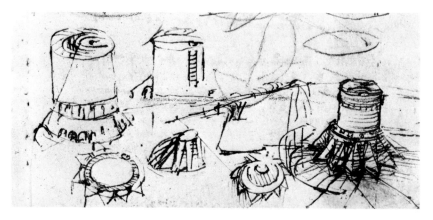

In the sketches above, Leonardo has recorded various shapes for a tower he projected in a fortification plan for the coastal town of Piombino, and at right studies for a catapult.

From time to time Leonardo was consulted as an expert in mechanical and military matters. He was an artist who could go beyond art, a scientist who accepted no limitations, a man who could go from the ancient world to a modern one.

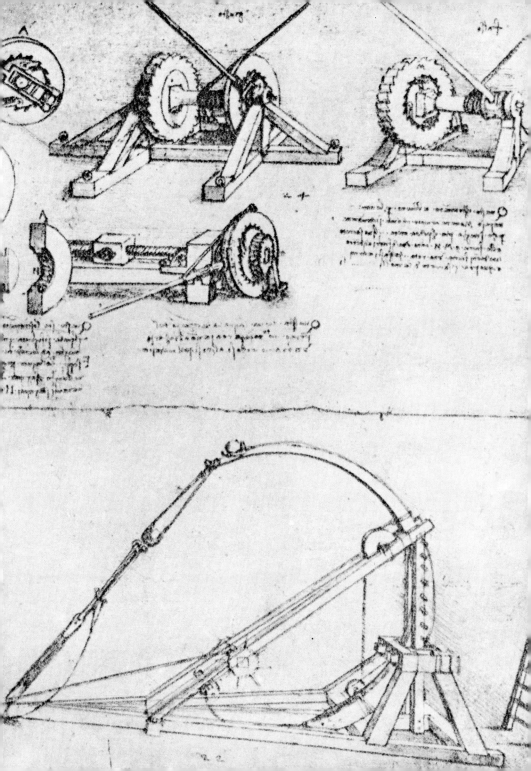

"He was the first, though
so young, to propose to canalize the Arno
from Pisa to Florence.
He made designs for mills, fulling
machines, and other engines...."
Vasari, *Life of Leonardo*

THE MILITARY

ARCHITECT

LUDWIG H. HEYDENREICH

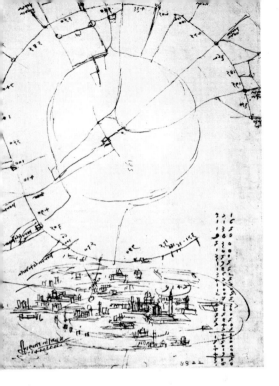

Leonardo's longest service was the 17 years he spent in Milan as architect, military engineer, painter, and master of ceremonies at the court of Lodovico Sforza. On this map of Milan, Leonardo drew the circular ground plan of the town and named the gates on its circumference. Below this he sketched a perspective view of the city, showing the main buildings, the cathedral in the middle and the Sforza Castle at the left.

The incessant wars and campaigns waged in Italy around the beginning of the 1500s in the course of the political conflicts between the great powers of France, Naples, Milan, Venice, and the Papal States – mainly concerning the upper and central parts of the country – brought with them a situation that gave rapidly increasing importance to the technical means of warfare, defense constructions, and military engineering. All involved parties, even the smaller powers, whether they were town republics or princely estates, had directives of the same sort: they were to maintain in the best possible condition their systems of defense as well as their means of attack. As new firearms, explosives, and artillery were developing quickly, basic alterations in the system of fortifications and technical warfare had become all the more imperative.

Thus new tasks of great import fell to the contemporary military architect and engineer, tasks that above all required an extended and specialized technical knowledge. In the early and middle decades of the 1400s Brunelleschi and Laurana had certainly been experienced fortress builders, yet towards the end of the century the professional position of the military architect came to be endowed with a very special character and increased esteem. The most important represen-

tative of this is Francesco di Giorgio Martini (1439-1501). Although respected as a painter, sculptor, and architect, he received the highest tributes during his lifetime as an ingenious master of fortification and as a strategic engineer. He occupied the position of chief director of building and waterworks in his native town of Siena, so that the entire architectural defense and hydraulic engineering of

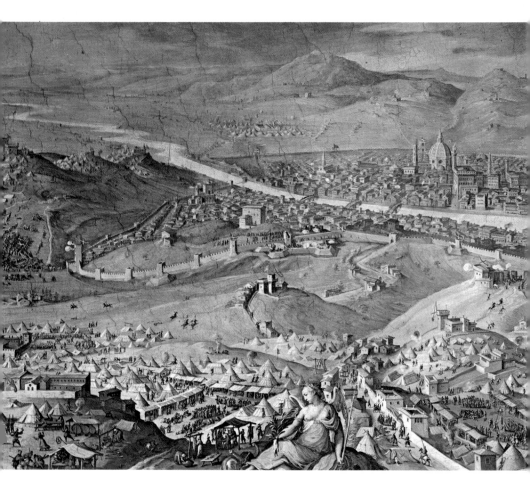

the city came under his control. The fortresses he built for Federigo da Montefeltro, Duke of Urbino, are impressive signs of princely power. Sassocorvaro (1470-1478), Rocca San Leo (1479) (p. 16), Cagli (1481), and the fortress constructed in 1501 for Francesco della Rovere at Mongavio still bear witness to this today. Francesco's *Treatise on Architecture, Engineering, and Military Art*,

which he wrote between 1480 and 1490 as the first comprehensive and systematically applied treatment of the subject, reached far beyond the works of his predecessors Taccola and Valturio, and it gained significant eminence in his time. In fact, in the declining years of the century, most of the architects of station were defense builders of experience. These names may be mentioned here as examples:

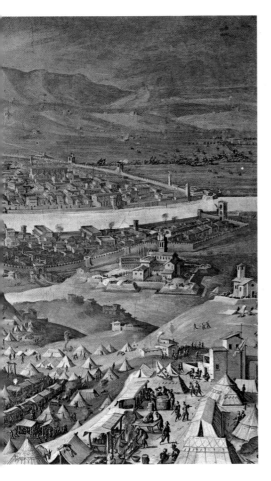

Leonardo's own Florence was a focus of many of the wars that raged up and down the Italian peninsula. In the painting (left) by Giorgio Vasari, troops of the Holy Roman Empire and the Papal States besiege the lovely city of towers to help the Medicis put down an attempt to restore the Republic of Florence in 1527. In such times of rapidly shifting alliances, when the existence of the state seemed constantly in peril, the most important of all the arts was war. Painters, sculptors, and architects were much in demand because many of them had the practical knowledge of engineering needed for the design of weapons and fortifications. Not surprisingly, Leonardo's letter of self-recommendation to the Duke of Milan strongly emphasized what was marketable: his skills as a military engineer and architect. Leonardo served several rulers and often switched sides after a war, apparently having little trouble rationalizing his military role.

Baccio Pontelli (1450-1492), who built the Rocca di Ostia; Luca Fancelli (1430-1495), Gonzaga's architect in Mantua, famous as engineer and canal builder in the Florence of the Medici; and the brothers Giuliano (1445-1516) and Antonio (1455-1534) da Sangallo.

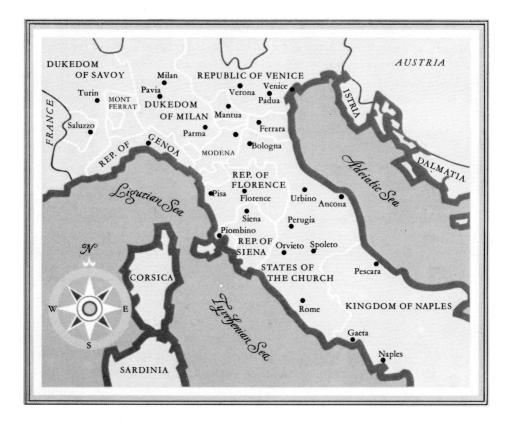

The map above reflects the concentration of powers in Italy at the beginning of the 16th. century: The States of the Church, (French) Lombardy, Venice, Florence, and Naples were the main powers.

During the six years after the downfall of his patron Lodovico Sforza (left) in 1499, Leonardo served several masters as military adviser: From left to right, Agostino Barbarigo, Doge of Venice; Cesare Borgia, Duke of Romagna; the Republic of Florence (arms); Jacopo IV Appiani, ruler of Piombino (arms).

So it seems only natural that Leonardo da Vinci, who was intensely occupied with the theory and practice of architecture throughout his life, should also from the very beginning have included the field of defense architecture and strategic engineering in his studies. Between 1490 and 1505, he served no less than five different masters as military architect and engineer. Until the fall of Lodovico Sforza in summer 1499, he was "ducal painter and engineer" at the court of Milan and functioned as expert for the installation of the duke's fortifications at Pavia, Vigevano, and Milan itself – although we have no more exact description of the nature of his work than that.

When Leonardo left Milan a few weeks after the triumphal entry of the French, he stopped off at Venice on his way to Florence. The government of the Serenissima, hard hit by the struggle at Lepanto on August 26, 1499, and worried by the possibility of a Turkish attack by land, seems to have taken the opportunity of Leonardo's presence to seek his counsel. A fragment of the draft of a letter to the governing council[1] attests that the master, evidently commissioned by the republic, traveled through the area that the Turks presumably intended to invade, the Isonzo valley in the Friuli, and considered artificial inundation of the area as an effective means of defense against the attacker. A small sketch map with the details "Ponte di Gorizia" and "Vilpago" is evidence for his presence there, but it is unknown how far his suggestions, which we can only infer from these outlines, were seriously considered.

This trip occurred in March 1500. By Easter, Leonardo was already in Florence, principally to exercise his function as a painter. But after only one and a half years

The fortress at San Leo shown on the opposite page was built in 1479 by Francesco di Giorgio Martini, whose systematic treatment of military architecture and engineering greatly influenced Leonardo.

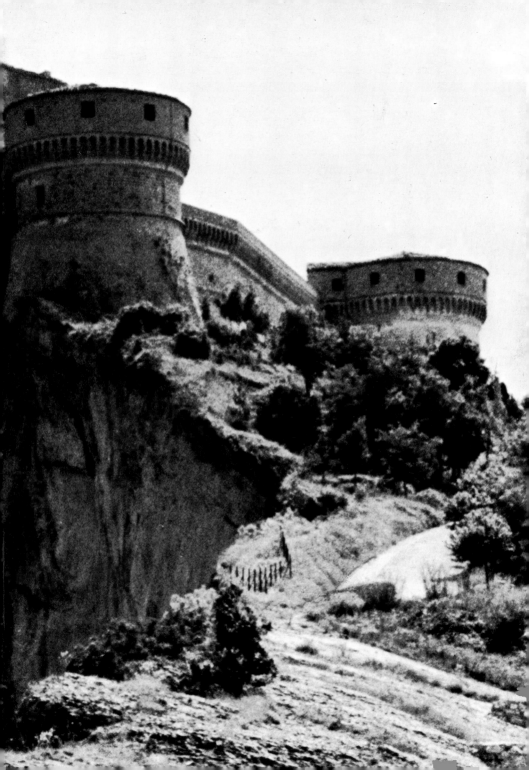

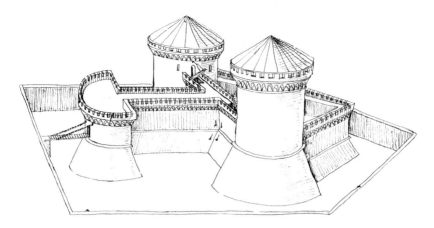

The contemporary who most resembled Leonardo in range of interests and talents was Francesco di Giorgio Martini (1439–1501). He was a painter, sculptor, and superintendent of buildings in his native Siena before becoming chief architect and military engineer for the Duke of Urbino. In 1495, during his service for Duke Alfonso of Calabria, Francesco suc-cessfully exploded a mine to cut a breach into the walls of the Castelnuovo in Naples, permitting the recapture of the important fortress from the French. He was one of the first to improve his fortifications with adequate means of defense against cannon fire and is known to have built well over 100 fortresses. Three of his designs from his Treatise are shown here.

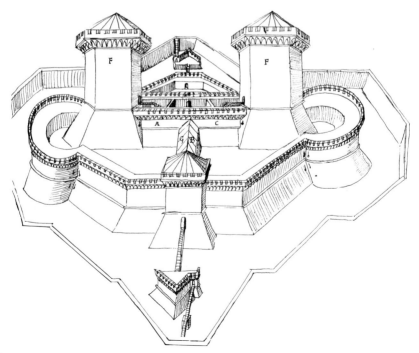

he took the surprising step of entering the service of Cesare Borgia as "architect and general engineer." Cesare Borgia, the son of Pope Alexander VI, marshal of the papal troops, Duke of Valentinois by the grace of Louis XII of France, was then indeed at the zenith of his short rise to fame. The Pope had just appointed him Duke of Romagna, thereby ousting the existing and legitimate rulers of the territory in the name of the church. Cautious Florence had "bought," so to speak, the good will of the dangerous and powerful neighbor through a treaty that made Cesare a condottiere of the republic, with an annual income of 30,000 gold ducats. No less a person than Machiavelli was delegated repeatedly and over long periods as chargé d'affaires at his court, and he had no other assignment than that of

The plan on this page shows Francesco's design for a harbor with semicircular breakwater. In Milan Francesco advised on the construction of the dome of the cathedral, and together with Leonardo, he went to Pavia in 1490 to consult on the construction of the cathedral there. Francesco gave Leonardo a copy of his famous Treatise of Architecture, Engineering, and Military Art, with designs of weapons and fortifications, that anticipated Leonardo's own manuscripts. Leonardo borrowed ideas for weaponry from it and in Codex Madrid II made intelligent excerpts of Francesco's plans for fortifications. Francesco's example added luster and prestige to the profession of military architect in the late 1400s, and thus Leonardo quite naturally took up the study of defense architecture and strategic engineering.

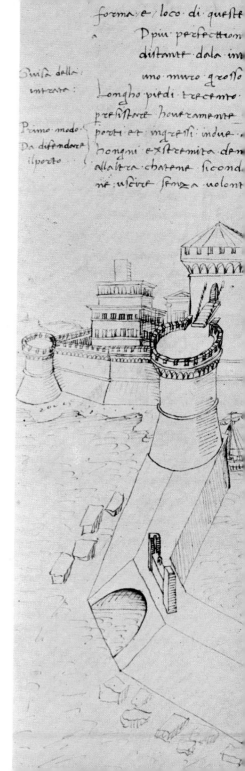

forma e loco di queste
D più perfectiom
distante dala im
uno muro grosso
Longho piedi trecente
presistere hontramente
porti et ingressi indue
longmi existremita den
allaltra charene ficond
ne uscire senza uolont

Visa della
intrata:

Primo modo
Da difendere
il porto

A sketch from the Treatise of Architecture, Engineering, and Military Art *(1480–1490), by Francesco di Giorgio Martini, showing a harbor design. The breakwater is fortified by towers at the entrance and exit to make certain that only friendly ships sail in and out.*

...a il manifesto:

...reza del porto si puo fare inmare
...occha sua p piedi dugento cinquanta
...xxx come appare linurei antedicti
...a chalice informa di angulo obtuso
...e licholpi dellonde delmare Questi
...ono essare difesi ilprimo facendo in
...grossa torre turando dalluna
...mio p le quali non sipossi ne intrare
...rincipi come appare disengniato:

political observer. His task was to report on the favorableness or the unfavorableness of the general situation. The "Duke of Valentinois," therefore, was certainly the most salient figure of the times. In this light even Leonardo's strange decision to enter the service of such a man seems to find a certain justification. For several months starting in summer 1502, Leonardo exercised his office as chief inspector of military building and accompanied Cesare on his conquering expeditions through Emilia and the Marches. Leonardo's diary of this journey is in the small Manuscript L in Paris, a notebook in which we can follow his exact itinerary in the company of Cesare. He records his halts in the region between Imola, Cesena, Rimini, Urbino, and Pesaro. However, apart from hasty jottings on an improvement of the docks at Porto Cesenatico, we gain no clearer insight into his official activity. Yet he had drawn up exact measurements of Borgia's area of operations. A part of the map he compiled of Tuscany and Romagna was indeed executed for this employer, as was Leonardo's magnificent plan of Imola (pp. 24–25).

Imola, under the rulership of Cesare Borgia after November 27, 1499, represented an important strategic base within the fighting terrain of the usurper. Leonardo must have drawn the town map during the autumn of 1502, at the time when Cesare armed his troops there for a new campaign against the condottieri and some members of the nobility who had allied against him. Around that period Machiavelli also was in Imola; he certainly must have met with Leonardo there.

The map is executed in color. Leonardo rendered the area of the city with great accuracy, as proved by a study sheet in the Windsor Collection[2] on which the individual sections have been surveyed properly and the fortifications as well as the town gates are sketched in. Similar preliminary studies of the towns of Cesena and Urbino in Manuscript L lead to the assumption that Leonardo designed a number of town plans similar in execution to the one of Imola, which, however, is the only one of its kind that has come down to us: a masterpiece of the "rationalizing fantasy" of the artist.

During the 1490s Leonardo sketched a map of the city of Milan (p. 11) which mostly remains within the tradition of the Middle Ages of sketching circular town plans, as is shown by comparison with a Milan map from the 13th century at the Biblioteca Ambrosiana and a version from a Ptolemy manuscript of around 1450.

In his beautiful drawing Leonardo draws the ground plan and a perspective view of the city. He was also familiar with the simple land-register plans, which were located at the municipal council.

From these established norms Leonardo arrived at his particular principle of representation, as can be noted for the first time in the map of Imola, truly an incunabulum of modern cartography.

From the remarks in Manuscript L, the fact clearly emerges that during this time Leonardo also visited the area of Piombino, another estate of Cesare's at the northern end of the Tyrrhenian Sea. This fortified harbor city, opposite the island of Elba, was important economically as a market for iron ore coming from Elba, and politically as a focal point between the bordering territories of the Papal States to the south, of Lombardy and Genoa to the north, and of Florence to the east. Borgia had already taken it, after a long siege in 1501, from its ruler Jacopo IV Appiani; and Pope Alexander had made over the ruling rights to Cesare. He included among his many titles that of "Signore di Piombino"; and it must have been an important preoccupation of his to strengthen this territory against enemies from without and from within.

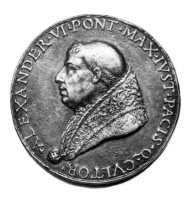

Cesare Borgia, the hero of the military and political power of the church under his father, Pope Alexander VI (above left), succeeded in occupying Imola in 1499 during the first of his Romagna campaigns. The following year, the Pope officially gave the town to his son, who commissioned Leonardo to study possible modifications. After the death of the Pope in August 1503 and the subsequent fall of Borgia, the town was eventually subjected to the Vatican, then under Pope Julius II (top right).

Overleaf: In his map of Imola Leonardo, like an aerial photographer, pinpoints every physical detail. The houses are tinted pink, the public squares dark yellow, the streets white. The city and its fortress at lower left are surrounded by blue moats. Across the map Leonardo drew lines, and at the eight points where they intersect the circumference, he wrote the names of the winds. Notes on either side of the circle refer to the geography of Bologna and other cities in which Cesare Borgia had a military interest.

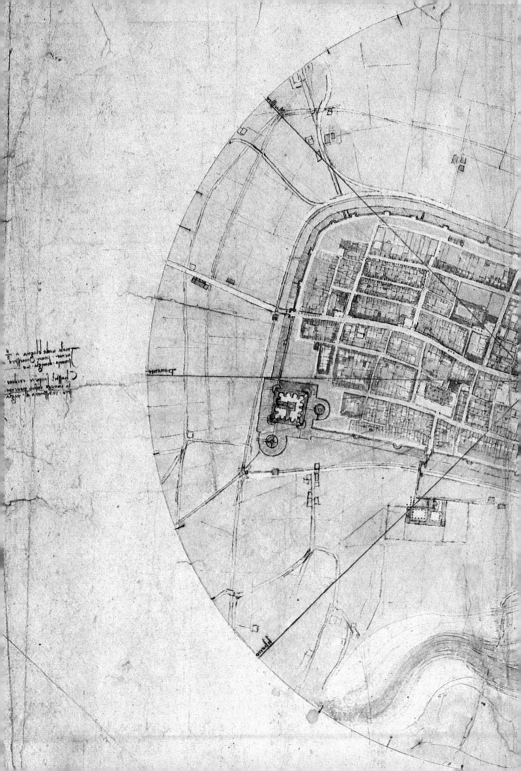

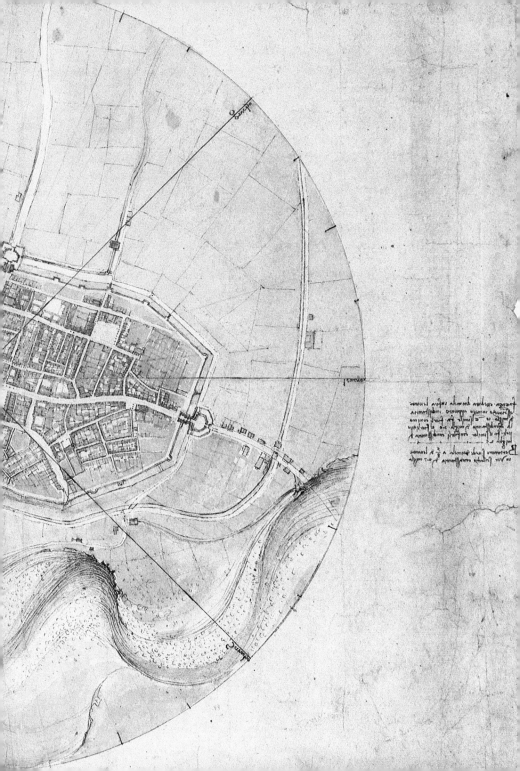

In Manuscript L Leonardo made geographic sketches of the spit of Piombino[3] and the whole Piombino coastline from the bay of the ancient harbor (Porto Vecchio or Porto Falesia) to the Gulf of Baratta, with its fortified site Populonia, of Etruscan origin.[4] In sketches on nearby pages, although it is unidentifiable in detail, one can conjecture the recording of a portion of the Maremma marshland bordering on Piombino.[5] These pages may be connected with a note in the Codex Atlanticus, "way to drain the marsh of Piombino," which dates from around 1503-1505.[6] That Leonardo must have been in Piombino during the period of his employment for Cesare Borgia is proved by a small sketch he made of wave movements accompanied by the text, "made at the sea of Piombino."[7] This fact, in the light of Leonardo's second stay in 1504, which has only become known to us through Codex Madrid II, will be seen to be of great importance later on.

One of the chief promoters of the scheme to divert the Arno was the Florentine statesman and writer Niccolo Machiavelli (left). He was then war minister for Florence, and he won support for the plan from the leader of the republic, Piero Soderini (right). Machiavelli knew Leonardo personally from their meeting the previous year in the camp of Cesare Borgia. In the summer of 1503 Leonardo was sent at least twice by the republic to the Pisa area for the control of fortifications and also apparently to study preparations for the Arno plan. Beside a sketch of the Arno in Codex Madrid II, folio 1 verso, he noted the date: "The day of the Magdalene, 1503" – July 22. Across a double-page spread, folios 52 verso and 53 recto, he drew the map at right showing the Arno and the area of military operations around Pisa. The map, which shows Pisa just to the left of its centerfold, appears to lack any plan for the diversion.

In the spring of 1503 Leonardo was again in Florence, having given up his post with Cesare Borgia probably during the course of the winter. His native town took him forthwith into its service as military engineer. Florence was then engaged in a troublesome and protracted war with Pisa. In 1406 Pisa had been sold infamously to the Florentines. In 1494, under the protection of Charles VIII of France, it had renounced its enforced subordination, and thereafter defended its

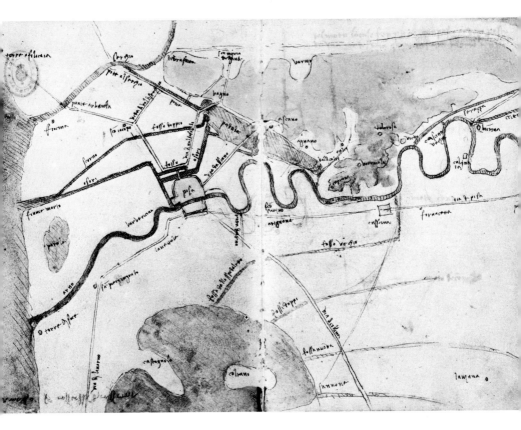

regained independence with passion and skill. In 1503 the Florentine Republic opened a new campaign against Pisa, and here emerged the daring plan to divert the course of the Arno River in order to cut off the Pisans from access to the sea, since from this the besieged town was constantly able to obtain supplies. Historical sources and documents reveal that the forceful project was especially promoted by Machiavelli, the secretary of state for war in the Florentine governing

council, and that it won the support of Piero Soderini, the chief official of the Republic of Florence. Unquestionably Leonardo had knowledge of it; but whether he had any part in drawing it up, as some older scholars believe, must be left undecided.

In any case, Leonardo was sent off in July 1503 by order of the council, to the Florentine camp to examine the work of trench digging which had been undertaken. For over a year the plan to divert the river was worked upon. It made provision for one canal, in the area of the estuary, that was to lead the water of the Arno off into the river Serchio, and for another canal from Vico Pisano to the Stagno di Livorno. The instructions of the Florentine council issued through the letters of Machiavelli to headquarters reveal quite clearly that the project had been planned in detail. Two thousand workmen in 150 to 200 days were to accomplish the enormous shift of earth necessary to dig canals approximately 40 to 60 feet wide, and 16 to 21 feet deep. The calculation proved to be erroneous. Five times as much manpower would have been necessary, according to the more realistic calculations of other experts, to complete the affair. Besides that, the work suffered considerable difficulties. It proved to be impossible to muster the thousands of workers required, or rather to keep them at work, especially since wages were frequently overdue. A completed section of canal did not withstand the mass of water fed into it and collapsed. Because of such setbacks, opinion was split among the commanders. Machiavelli defended his idea in entreating letters and reports to the council until autumn 1504, but in vain. In October the enterprise was definitely broken off – much to the triumph of the Pisans. The Florentines had to fight another five years for Pisa, for only in 1509 did the exhausted city give itself up.

To us, judging the affair today, it seems almost inexplicable that men of such realistic disposition as Machiavelli and Piero Soderini could have succumbed to

Leonardo had an abiding interest in changing the course of the Arno – but not to cut Pisa off from the sea. He wanted to create a great waterway to open Florence to the sea and bring agricultural and economic benefits to all Tuscany. The Arno was not navigable from Florence to Pisa because of its tortuous bends and sudden variations in level. The idea of diverting a long section of it into a man-made canal dated back more than a century before Leonardo's birth. From about 1490 on, Leonardo made it his own and drew a number of maps and studies. Here, in Codex Madrid II, folio 2 recto, he traces the serpentine course of the Arno from Pisa at the bottom to Empoli, which is near Florence. Between the towns along the river he notes the distances.

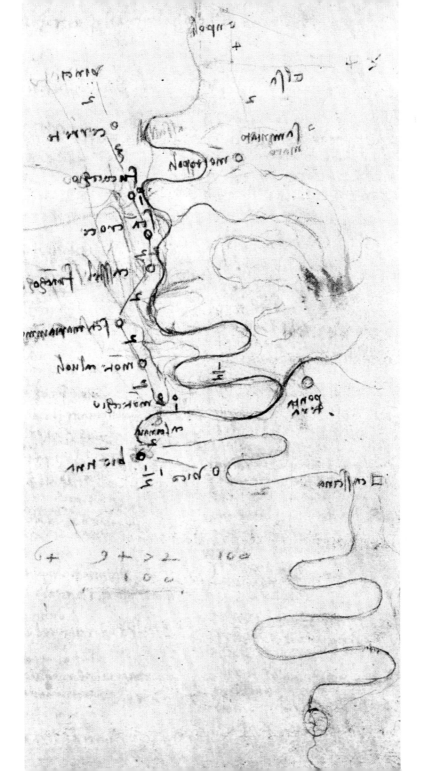

29

*I found that the complete excavation
of the moat, which is, on average, 17 braccia wide,
and 16 braccia deep, and 640 braccia long, reduced to
square braccia, amounts to 174,080 braccia. Which
reduced to square canne, amounts to 2720 canne.
Of which, those at the mountain, due to
the difficulty offered by the rock, deserve 5 lire
the canna, an amount paid on other occasions to
the diggers.* MADRID II 10r

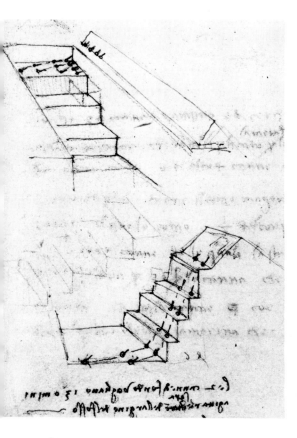

Scholars now doubt that the Florentine scheme to divert the Arno was originated by Leonardo. The plan called for digging canals nearly 60 feet wide and 21 feet deep to carry the river as much as 7 miles off its normal course. He must have known from the beginning that such a feat would be difficult in peacetime and virtually impossible under wartime conditions. He also had the practical knowledge of a time-and-motion expert and could figure out how much digging men could do, how they ought to do it, and what it would cost. The diagram at left—part of his plans for an excavation at Piombino in Codex Madrid II, folio 10 verso—and the transcription above make clear his closely detailed approach to such projects. His tiny figures on the top set of stairs indicate that getting the dirt out of the trench handily would require more workers near the edge of the excavation. He also was aware of the inefficiency of men equipped only with hand shovels, and he designed the big treadmill-powered digging machine shown here from Codex Atlanticus, folio 1 verso-b. For the Arno plan Leonardo's Florentine superiors had calculated it would take 2,000 workers about six months to dig the necessary canals. They miscalculated by a multiple of 5. One section of the excavation collapsed, and though Machiavelli tried to push the scheme, the project was abandoned.

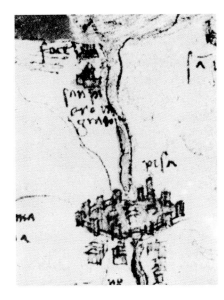

The city of Pisa – shown in the map (left) – figured in a bold Florentine scheme that involved Leonardo. The Pisans, under Florentine rule since 1406, had renounced their subordination in 1494, and successfully defended their independence thereafter. In 1503, when Leonardo returned to Florence to serve as military engineer, his native town had the daring plan to divert the course of the Arno River and deprive the besieged Pisans of their supply lines to the Ligurian Sea.

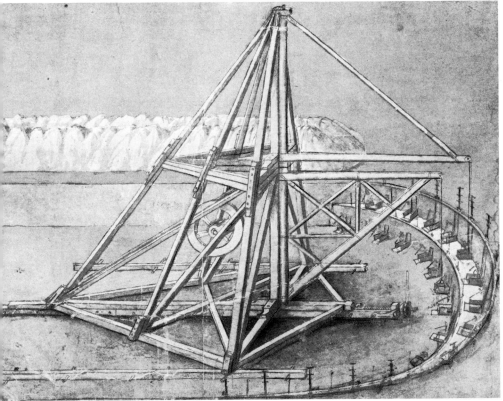

such an idea, which to every reasonable thinker must have appeared utopian from the beginning. To divert a river of the volume and current of the Arno, and over such a long distance – a diversion of 7 miles in one place was talked of – was certainly an undertaking that could never be carried out in such a restricted period of time as was actually and strategically provided during the siege of Pisa. In spite of that, the contemporary engineers, experienced hydraulic experts from Florence and Ferrara who had been sent to the site, must have considered the task to be feasible at first. Critical voices got very loud very soon, however, and when the enterprise collapsed, there was no lack whatever of bitter comment.

Leonardo's exact position in this scheme is very difficult to determine. The facts that he was appointed adviser by the government and that he accepted the task lead us to conclude that he must have been entrusted with the plan. But his own judgment is unknown; and from the new material that has come to light in the Madrid notebooks we must deduce that he was not as some have believed, the originator of the idea, but rather that he remained undecided and certainly very critical.

In Codex Madrid II there is to be found only one reference to Leonardo's presence in the camp at Pisa (p. 27). This is something like an ordnance map, drawn over a double page, of the area of military operations around Pisa, extending to the sea. The topographic names inserted – for example, Serchio, Arno, Torre di Foce, Verrucola, Vico [Pisano], Cascina, Calci – correspond exactly to the places named as centers of operation in the letters between Machiavelli and the leaders of the camp. In this way, the canal courses (*fossi*) plotted in the estuary area of the Serchio (*fiume morto*) north of Pisa, as well as those between the Arno and the Stagno di Livorno to the south, provide an exact survey of the canal network in this sector of the coast. Leonardo's place names are written in a normal hand and not in mirror writing, so that this map was certainly destined to be submitted to his employers. But we cannot infer from the map any proposal or plan of execution. Nor elsewhere in Codex Madrid II is there any more information on this project. From an entry on one sheet in the Windsor Collection we can much rather infer Leonardo's doubt over the undertaking. This inference gains more weight in that a large number of additional drawings have been preserved in the Madrid Codex which are indeed concerned with the course of the Arno River, but which have quite a different, pacific theme as their subject.

To amplify, on one double page of the codex is a colored map of the course of the Arno from Florence to the estuary behind Pisa and to the sea (pp. 34–35). The two

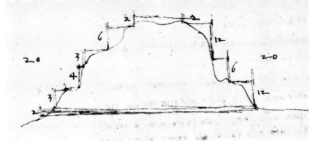

The mammoth scope of Leonardo's plan to open Florence to the sea is shown in the map (overleaf), Codex Madrid II, folios 22 verso and 23 recto. The Arno can be seen snaking across the double-page spread from Florence at the lower right through Pisa at the extreme left. The two lines curving north from Florence indicate the alternate routes Leonardo studied between Florence and Pistoia: one to the east through Prato, the other via Poggio a Caiano. From Pistoia the proposed canal skirts Monte Albano, cuts through the pass at Serravalle, and runs south to link up with the Arno at Vico Pisano. This, in part, is the route followed more than 450 years later by the builders of the autostrada – superhighway – from Florence to the sea. In the diagram at top, from Codex Madrid I, folio 111 recto, Leonardo shows an intention to tunnel through Serravalle – the same place chosen by the autostrada engineers for their tunnel.

This map, Windsor No. 12279, is another study for the Arno canal. Leonardo is precise about distances – he says the canal will make the waterway 12 miles shorter – and benefits: "Prato, Pistoia, and Pisa, as well as Florence, will gain 200,000 ducats a year, and will lend a hand and money to this useful work."

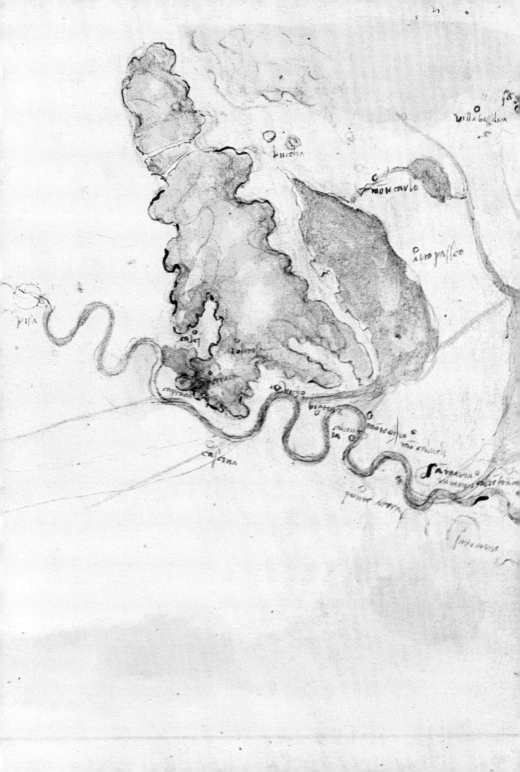

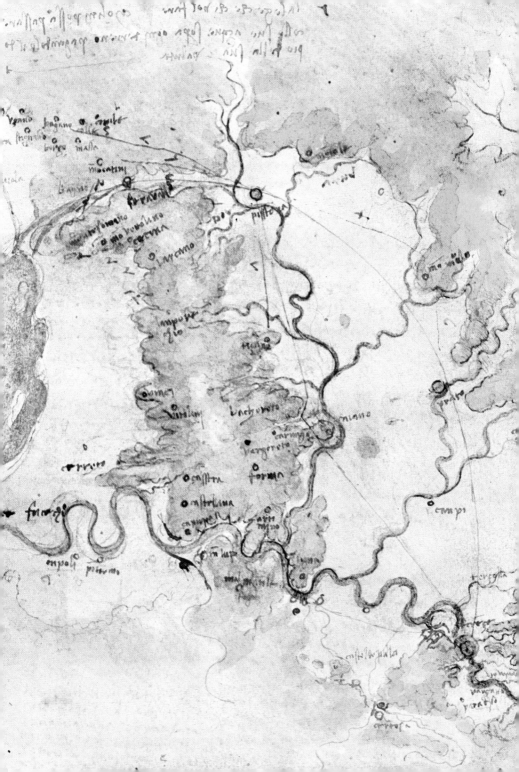

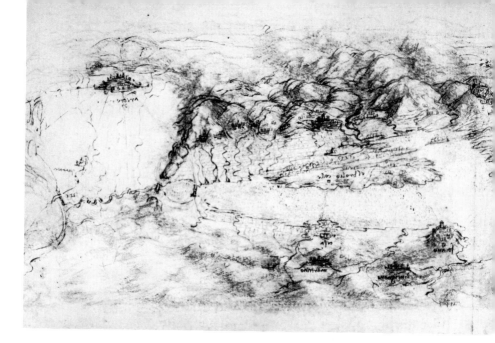

groups of mountains north of the river – Monte Albano with its foothills from Serravalle to Signa, the Pisan mountains from Lucca to Vico Pisano – are set down against the wide plain. A large number of place names have been entered by Leonardo, again in normal script. On the Windsor sheet there is a preliminary study of the map in the Codex Madrid (p. 33). The nature or purpose of this topographic diagram becomes evident: Leonardo inserts the course of a large canal, which, by forming a detour of the unnavigable part of the Arno with its sharp bends, was intended to create a waterway between Florence and Vico Pisano. What Leonardo tries out with various attempts on the Windsor sheet is brought to a final solution in the map of the Codex Madrid. We recognize the great sweep of the canal leading from Florence to Prato to Pistoia (with an alternative route via Poggio a Caiano), and from there through the valley of Serravalle back again into the plain to return finally to the Arno at Vico Pisano. The idea of rendering the Arno navigable from Florence to the sea by means of a canal was old. As early as 1347 the Florentine governing council determined to set its hand to such a task, and it did so again in 1458. In 1487 the architect Luca Fancelli of Milan reminded Lorenzo de'Medici of such a project which he had discussed with the latter's father Piero. Thus Leonardo was taking up a long existing suggestion, the two economic aims of which he made his own: the creation of a waterway to the sea, with the compensation arising from the hydraulic works, and the provision of further territory for agriculture. And it seems that he concerned himself with the

The maps shown here seem at first glance to have been drawn from the air, as if Leonardo had been able to construct and pilot aloft his flying machine. His imaginary perspective brings together previous views and fragmentary studies that he had made at first hand. Both maps, Windsor Nos. 12682 and 12278 recto, show Arezzo and the valley of the Chiana, or Val di Chiana, and probably were made in 1502 when Leonardo was in the service of the notorious Cesare Borgia. In the bot-tom map the place and river names are entered in careful left-to-right lettering, an indication that this was most likely a military map for Borgia's use. In the center is the Val di Chiana, at that time a swamp, with the Arno streaming out to the left towards Florence. The Val di Chiana and the Tiber River, at top, figured in Leonardo's plans for the Arno project – as a means of main-taining the river at an even level for navigation.

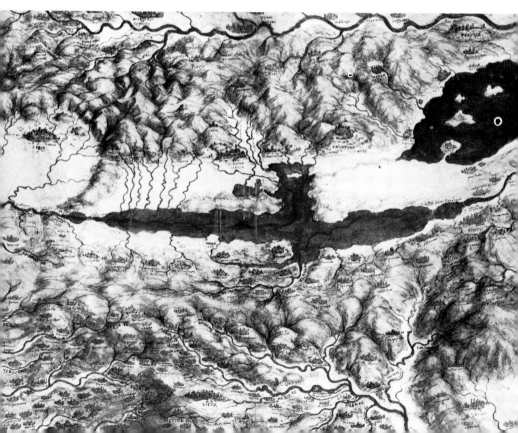

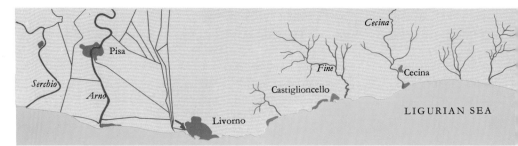

The coast of the Ligurian sea can be seen along the bottom of Leonardo's map of the Arno watershed in northern Italy. The swamps near Pisa have been drained since, as can be seen in the map.

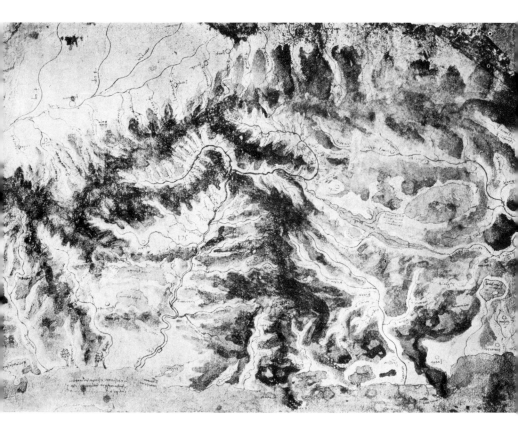

project as early as his Milanese years. Many of his relevant drawings and studies must date, for stylistic reasons, from the 1490s.

Leonardo developed this great project on several pages of the Codex Atlanticus.[8] Experienced scholars have examined it and investigated its practicability. The

Leonardo drew the map at left during his service for Cesare Borgia, 1502–03, and it contains the borders of Cesare's ambitious "kingdom" as a ruler of central Italy. Even though the map was also drawn for strategic purposes, it is the masterpiece of Leonardo's long-term studies of the Arno river and its tributaries – and perhaps the first modern map. It anticipates in execution as well as viewpoint the work of present-day map makers. Leonardo indi-

cates by dark shadings the mountains of the Apennines and carefully shows and names the rivers, lakes, and towns. From the sea the Arno winds up through Pisa and Florence (near center); then, at the junction with the Sieve river, turns south towards Arezzo and back towards the north. The map below, of the Arno and its tributaries, rendering the central area of Leonardo's map, attests to his remarkable accuracy.

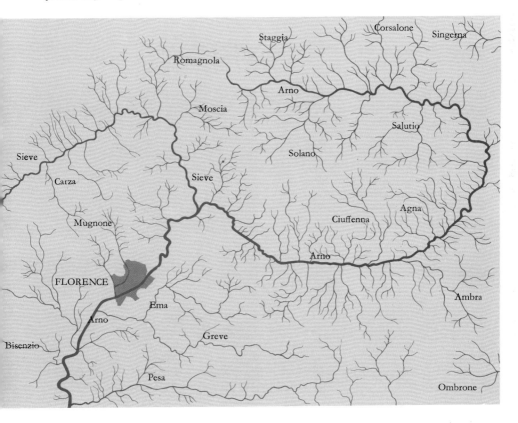

sensible calculations given of the daily working capacity of a digger, which serve as a basis for calculating the whole enterprise, are hardly consistent with an overly utopian conception. Because of the difference in level to be overcome (some 263 feet), the canal through Serravalle would have necessitated either the construction of a flight of locks of great dimensions or the building of a tunnel through the mountain. Leonardo indicated in Codex Atlanticus an intention to tunnel through Serravalle – exactly where the builders of the modern *autostrada* from Florence to

As part of his own Arno project, Leonardo must have spent many days traveling up and down the river to observe the difficult terrain the canal would have to traverse. Characteristically, he recorded what he saw in a few words and many masterful drawings.

Here, from Madrid II, folio 4 recto, he sketches Monte Veruca with the fortress that crowns its craggy summit, and fills up the space below with engineering calculations. The citadel atop Veruca, which had been recaptured by the Florentines in their war with Pisa in 1503 and inspected by Leonardo on June 21, was the outermost bastion in the much disputed border area. It still stands today (see photograph).

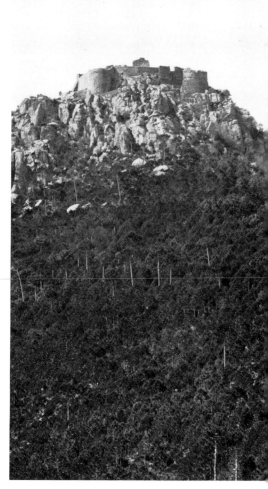

the sea did. Years earlier he had studied the problem of perforating a mountain. In Codex Madrid I there is a description of how to pierce a mountain (p. 33) with a measuring device designed to guarantee that two tunnels started on the opposite sides of the mountain would meet each other at the right point.[9] Codex Madrid I belongs to Leonardo's years in Milan, and so would correspond approximately with the time when he met Luca Fancelli there. It is a somewhat bold but nice hypothesis that the two Florentines may have discussed together that great prob-

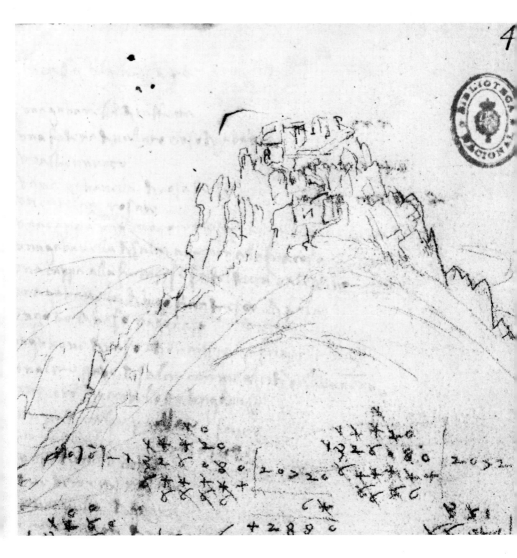

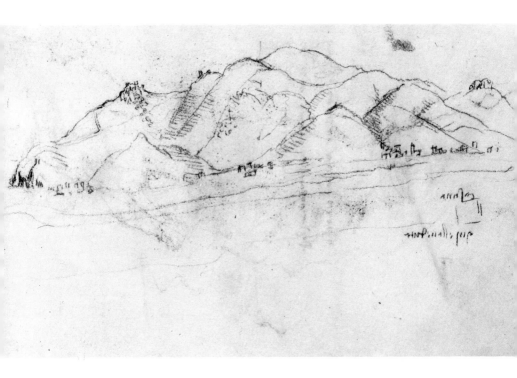

The sketch above, from Codex Madrid II, folio 7 verso, presents the mountainous panorama of the so-called Pisan Alps on the sides of the Arno.

lem of their home country, the Arno canal. Whatever the case may be, when in 1503 Leonardo was sent in his capacity as strategic engineer to the camp at Pisa to inspect the efforts to divert the Arno from the city, he certainly discharged his duty conscientiously, as is shown by his "ordnance map" of the operational area in Codex Madrid II (p. 27). But it is comforting to note that the master's main interest remained not the war objective, but the peaceful project of the Arno canal as a waterway.

Leonardo was certainly aware of the extent of the latter venture and of the technical difficulties connected with effectuating it, as is attested by notes in his manuscripts of a warning character.[10] His planning should, for this reason, be understood as a lengthy and systematic study of all factors; and the drawings in

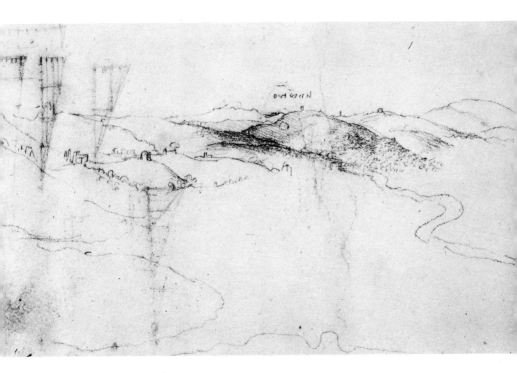

In Madrid II, folio 17 recto, he draws the mountain range of Incontro above Florence, shading in the heavy shrubbery on the slopes (above).

Codex Madrid II offer the best evidence of this. They complement studies in the Codex Atlanticus and the Windsor Collection in an enlightening fashion and show Leonardo at work on a project of the highest economic importance. It appears that these studies were broken off following his departure from Florence in 1506.

The collapse of the plan to rob besieged Pisa of its access to the sea led to the temporary suspension of military action. The Florentine troops were recalled and all the more therefore did the governing council seek to isolate the enemy through political and diplomatic channels. In April of 1504 Machiavelli was sent to Piombino to treat with Jacopo IV Appiani – who had returned to his city after the fall of Cesare Borgia – and to resume friendly relations with him. The mission was delicate. Only a few years before, in 1499, Machiavelli had had an eye on

43

winning Jacopo over to Florence with a highly paid post of condottiere. The negotiations had dragged out, but then, as Borgia's star was rising, were evidently broken off on the Florentine side, since it seemed to the Florentines more advisable to strike up good relations with the favorite of the Pope. Instead of Jacopo Appiani, they offered the position to Cesare Borgia and accorded him the title of "Signore di Piombino" before he had taken up possession of the territory. So in 1504 Machiavelli had a difficult diplomatic mission. He had first of all to win

In his rendering of mountainous land-
scapes, Leonardo's roles as artist, engineer,
and geologist fuse, and visual magic results.
The haunting landscape details at top are
from St. Anne and the Virgin (left) and
the Mona Lisa. The drawing, Windsor No.
12410, follows his own advice: "O painter,
when you represent mountains, see that . . .
the bases are always paler than the summits
. . . and the loftier they are the more they
should reveal their true shape and color."

back again Jacopo Appiani's confidence in the governing council of Florence;
second he had to ensure what we would call today the "benevolent neutrality" of
the ruler of Piombino in the strained relations that Florence had with Siena and
Pisa. With regard to Pisa, which the Appiani four generations previously had had
to leave ignominiously, Jacopo's "benevolent neutrality" was not difficult to
obtain. It was much more important to Florence to engage his neutrality towards
Siena. Machiavelli's diplomatic task was exactly laid down by the council. In 1504,

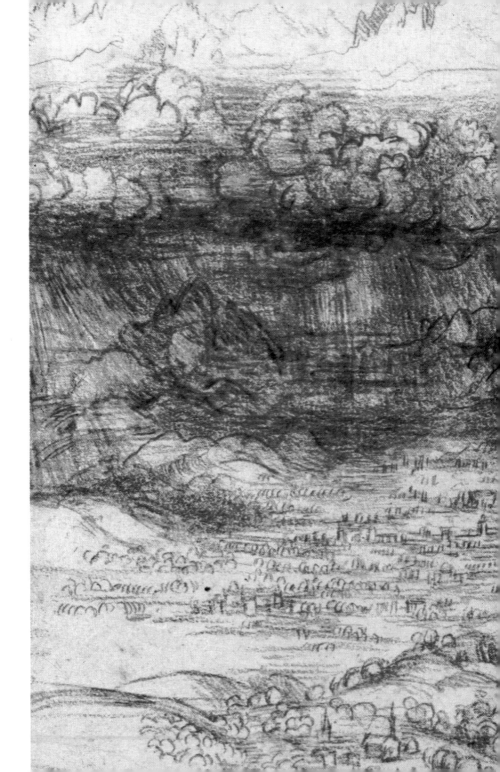

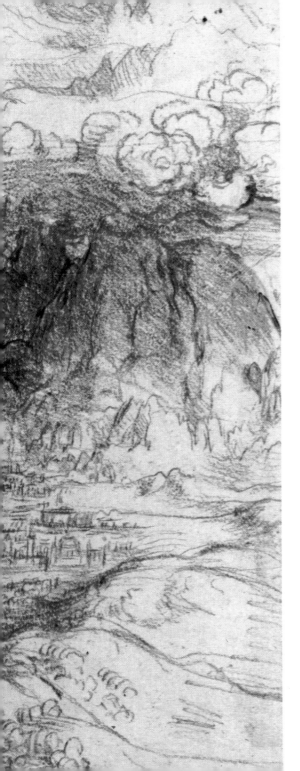

As shown here Leonardo asserted his vivid imagination to create new perspectives made from viewpoints that then existed only in his mind. The drawing, Windsor No. 12409, looks down at a town in an Alpine valley where a storm is breaking and up to the sunlit peaks above the storm.

47

therefore, he betook himself to Piombino, and it is certainly no accident that in the late autumn of that same year Leonardo da Vinci also went to Piombino to advise Jacopo Appiani on the building of the fortifications of the city. This task, up to now unknown, is new information afforded to us by Codex Madrid II.

On one page of this codex we find Leonardo's entry, "The last day of November [he must have meant October], All Saints' Day 1504 [actually November 1], I made in Piombino for the Lord this demonstration."[11] The text is accompanied by a small drawing which envisages the leveling of a group of hills in the framework of the defense installations (p. 56). On the previous page there is a sketch of a

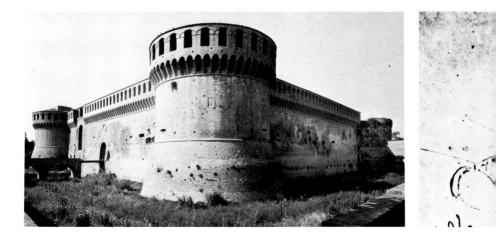

tunnel (p. 58). The accompanying text says, "covered way; fortress (i.e., citadel) of Piombino the 20th of November 1504; the moat which I am straightening."[12]

The date November 1, 1504, is found once more in the codex in an entirely different context. Leonardo notes down an observation on green-colored shadows on a wall of a house; above the note is written, "1504 in Piombino, All Saints' Day."[13] At the end of December, presumably before Christmas, Leonardo is once more in Florence, as we know from other documents. Since he had withdrawn money there on October 31, 1504, he can only have traveled to Piombino from that day onward. On the very next day, after his arrival in the place, he explains his

plan of construction to the "Signore," Jacopo Appiani. It is therefore obvious that he must have already had exact knowledge of the local situation and of his task. This causes us to reflect a little. He then spent 6 to 7 weeks in Piombino, which is an exceedingly limited period that must exclude the possibility of large building operations having been carried out under his supervision. From all these circumstances we must deduce that there in Piombino, in the same way as in Venice and in the siege camp at Pisa, Leonardo worked as expert and adviser rather than as practical architect.

There can be no doubt, in my opinion, that Leonardo da Vinci's task was con-

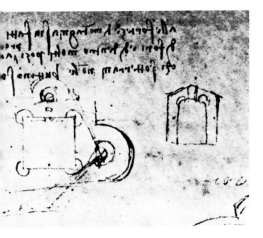

In October 1502 Leonardo spent several weeks in the city of Imola with its leader Cesare Borgia, who had been detained by a revolt of his generals. During that period he studied the existing fortress there. The fortress, called the Rocca, is shown in a 17th-century drawing on the following pages and in a photograph after its modern restoration (far left). Leonardo's sketch (left) for a fortress with towers protected by semicircular moats in the Codex Atlanticus, folio 48 recto-b, may have been inspired by the Rocca.

nected with the political mission of Machiavelli. It seems only logical that the Florentine diplomat should offer to place at the re-enthroned ruler's disposal the most famous expert of Florence for advice in the most important task before Appiani: the fortification of the town he had won back again. Leonardo was the most suitable person, as he had already been fully entrusted with the same job during his period of activity for Cesare Borgia, that short-lived usurper of Piombino. So it was that in the irony of the game of historical circumstance, Jacopo Appiani came to profit by the very defense project that had originally been elaborated for his hated enemy.

TAVOLA
DELLI LVOGHI NOTABILI NELLA ROCCA D'IMOLA

A. *Sarminero Risellino auanti la Porta della Rocca*
B. *Ponte di legname stabile*
C. *Mansione di guerra murata trà un Ponte e Saleto*
D. *Ponte di legname per alcare*
E. *Ponte di pietra formato sopra vna Archi fondati nella fossa*
F. *Ponte di legname per alcare*
G. *Porta maggiore della Rocca*
H. *Porticella per quanin onero alzato il Ponte*
I. *fabrica dentro la quale sono le scale g saliue di sopra*
K. *Chiesa di Santa Barbara*
L. *Appartamento di sopra per seruitio del Comandante*
M. *Peggolo o Rimganeo con sua Brella per torraui l'acqua*
 al Dorno di sue nella prima Piala d'Armi
N. *Prima Piazza d'Armi*
O. *Sarriore dino della Cucina*
P. *Cenestare e ric rara nella Cocina al Maschio*
Q. *Sarriore dino della Polueri*
R. *Scale Lumaca per discendere nelle Cantine*
S. *Secondo Piala d'Armi*
T. *Andito per doue andana alla Porta del Soccorso che sotto*
 copona vro Ponti Sanina di Riuellino et alla campagna
V. *Riuellino della Porta del Soccorso*
X. *Piazze li Pillastri che sostengano e Ponti*
Y. *Altra Abitazione da bino*
Z. *Maschio*
&. *Sarrina sino della Porta di Bologna*
AA. *Vestigi d'un Arco*
BB. *Managlia della cina*
CC. *Sarriore dino della cina*
DD. *Scala per salire di sopra*

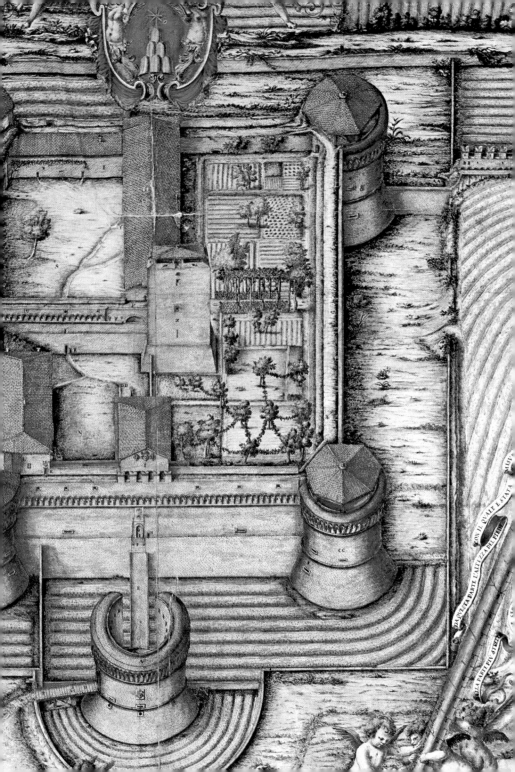

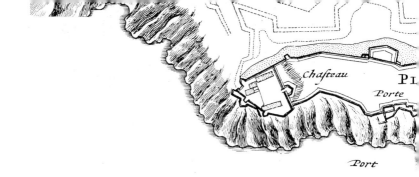

Four different yet related construction projects concerning the fortification plans in Piombino can be singled out among Leonardo's sketches and notes scattered throughout Codex Madrid II. Each individual project leads out from the citadel located at the east corner of the town.

The keystone of the defense of the city was the citadel that can be seen rising from the right portion of the map above and in the middle of the 1894 painting shown at right.

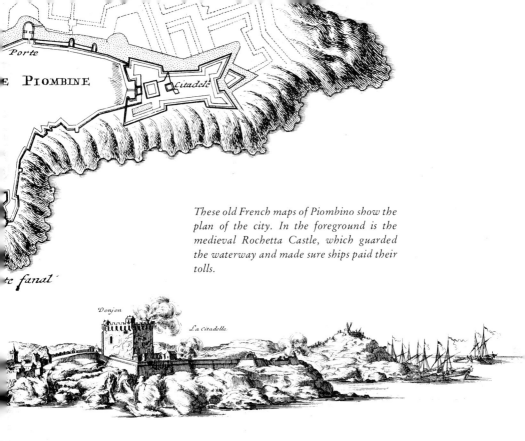

These old French maps of Piombino show the plan of the city. In the foreground is the medieval Rochetta Castle, which guarded the waterway and made sure ships paid their tolls.

The first of these projects was to dig a trench 640 braccia (about 1,260 feet) long, leading through rocky ground from the citadel to the spit of the land and the Rochetta.[14] According to modern maps of Piombino, the distance from the citadel to the spit is 1,312 feet, which corresponds closely to Leonardo's figure.

Military commissions from two different masters took Leonardo to the charming port city of Piombino on the west coast of the peninsula. His two visits led to several ingenious ideas for fortifications. The illustrations on these two pages – all from the 19th century before the deterioration of old Piombino – show what the city must have looked like when Leonardo first went there in 1502 for Cesare Borgia. Porto Falesia, a harbor which was important ever since Roman times, bustled with ships bearing iron ore from the island of Elba a few miles away. Ships passing through the narrow waterway between or stopping for fresh water were charged a toll. The receipt for payment was a little lead coin. According to tradition, Piombino got its name from the Italian word for "little lead" – piombino.

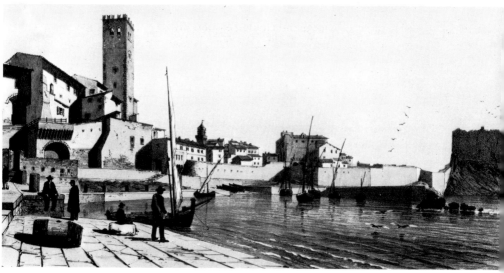

The second project was to build a tunnel – a "covered way" which was also called "moat" (*fosso*) – the length of which was indicated by Leonardo to be 300 braccia (590 feet). This was to lead in a straight line from the citadel to the town gate of Piombino.[15] According to the modern city maps the distance from the citadel to the town gate actually corresponds very closely to the figure stated by Leonardo.

The purpose of Leonardo's first visit to Piombino was to study draining the marshes there and to improve the fortifications. Piombino had great strategic interest for Florence, Siena, and the other powers around it. In 1499 Borgia had deposed the ruler of Piombino, Jacopo IV Appiani. But by 1504 Borgia was expelled and Jacopo was back in power. Florence wanted to regain Jacopo's friendship, so Machiavelli was sent as an ambassador in the summer, and at the end of October 1504 Leonardo was dispatched to Piombino to help with the defenses. He obviously had a rather exact knowledge of the situation – drawn up for his erstwhile patron and Jacopo's enemy, Borgia. The evidence in Codex Madrid II indicates that Leonardo was in Piombino six to seven weeks. He

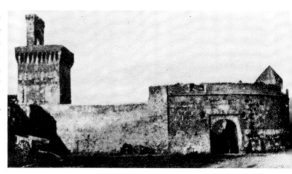

drew detailed plans and made notes for a number of projects (see following pages). No one knows whether any actual construction was carried out, though the tower at the main gate (top photograph) is still known to inhabitants today as "the tower of Leonardo da Vinci."

Third, it was intended to enlarge the citadel, essentially by constructing a massive tower with a height of 20 braccia (39 feet, which is not very much!) and a diameter of 25 braccia (49 feet).

Fourth, it was planned to level some hill land in order to achieve an open line of fire for the rather small, fortress-like tower. With his firearms Leonardo would have controlled the open area in the east, around the port.

With relative accuracy only the tunnel between the citadel and the town gate may be located. As to the shape of the tower, Leonardo recorded various differentiating sketches and notes. There cannot, therefore, be singled out one final plan concerning the tower's exact position within the entire complex of the fortification or concerning its construction. Neither can there be found further details of the plan for the 640-braccio-long trench. The repeated notes concerning the rocky terrain (causing the project to be more expensive) and the note *lungo la marina* ("along the coast"), however, lead with certainty to the assumption that this trench was to reach the spit of land.

During the weeks Leonardo spent in Piombino, work seems only to have commenced on the tunnel, or "moat," from the citadel to the town gate, as can be gathered from the note "the moat which I am straightening." The remaining projects apparently were left unexecuted.

That Leonardo advised Jacopo Appiani on the fortifications of Piombino in 1504 is new information afforded to us by Codex Madrid II. The text is accompanied by this drawing which envisages the leveling of a group of hills in order to achieve an open line of fire from the round tower to the old harbor.

Above right: A sketch from Codex Madrid II, folio 88 verso, in which Leonardo reconstructs the old harbor (Porto Falesia) with its breakwater that even then had fallen into ruin. At the left of the breakwater he designs a fortification to guard it.

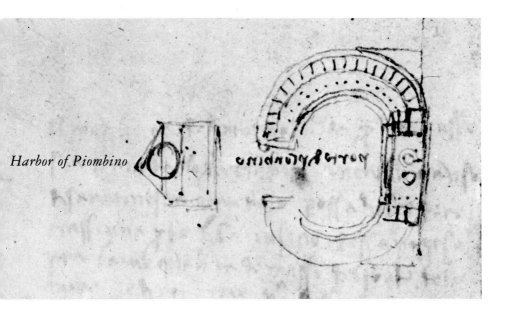

Harbor of Piombino

The accompanying comprehensive texts, mostly calculations of cost, disclose that Leonardo was a well-versed engineer who differentiated exactly the daily capacity of a man according to the sandy or rocky nature of the ground. For the construction of the tunnel, or "moat," Leonardo also provides exact specifications for expedient distribution of labor, ranging from the deepest level of the tunnel to the uppermost edge of the rampart, so that the masses of earth can be disposed of freely and easily.[16]

Though mathematically quite primitive, Leonardo's calculations of the masses of earth to be coped with in removing the hills are extremely interesting. His method of dealing with cubic mass is somewhat empirical, and one would not like to guarantee the exactitude of the calculations. However, the transposing of a hill massif into a geometric cone diagram and the evaluation of the volume of the cone show that he resorted to a certain mathematical principle in order to formulate the real dimensions of a practical task.[17]

Most enlightening indeed, as far as the political conditions of his times are concerned, is the precaution Leonardo took of safeguarding the covered connecting passage between fortress and town gate against not only the external but also the internal enemy. In case *il popolo* – i.e., the townsmen of Piombino – were to

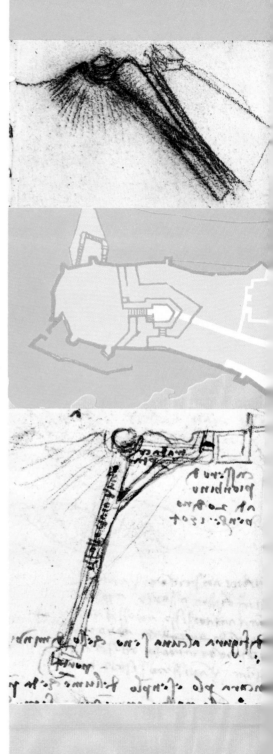

On this 16th-century map of Piombino are superimposed the four main tasks Leonardo meant to undertake for Jacopo IV Appiani. The biggest project was the digging of a trench from the citadel to the Rochetta at the spit of the land (I). This trench was to measure about 1,260 feet. Next he wanted to connect the citadel by means of a tunnel with the main gate of Piombino (II). Two sketches from Madrid II, folios 9 verso and 24 verso (left, top and bottom), show the tunnel. This passageway was to be 590 feet long and was to serve as a means of communication and, if necessary, escape for the ruler of Piombino. To protect the ruler from betrayal by his own soldiers or townspeople, a common occurrence in those days, Leonardo planned to construct a drawbridge as the only means of reaching the tunnel. Next to the fortress and branching off the underground passageway, he designed a round tower (III) to help defend the fortress and the old wall. Sketches for this project are shown at far right, both details from Madrid II, folio 37 recto. The fourth project involved leveling some hill land in order to achieve an open line of fire.

covered way

fortress of
Piombino
the 20th
November 1504

the moat which I am straightening

door

58

The small map of Piombino at right plots a new wall outside the old one and builds up the defenses around the main gate. Though found in the Codex Atlanticus, folio 41 recto, it was drawn by someone other than Leonardo – perhaps Antoni da Sangallo the Elder, a noted Florentine architect and engineer, who was in the service of the republic at the same time.

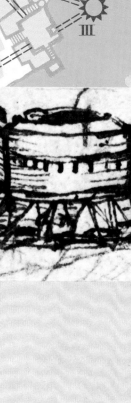

rebel against their lord and master and attempt to cut off the passage to the town gate, Leonardo provides a countermeasure and safety device. It is an eloquent illustration of the mistrust under which a ruler of those days exercised his position.[18] Again, in the construction of the great round tower of the citadel, the kernel of the fortifications, a system of preventive measures is provided to control the functions of the commander of the fortifications so as to exclude every possibility of betrayal to the enemy as well as surprise attack. The disgraceful surrender of the mighty citadel of Milan – which the commander abandoned in 1499 to the French after they had penetrated the city, thereby setting the seal to Lodovico Sforza's defeat – may well have been in Leonardo's mind. He may have been thinking, too, of the surprise attack on the fortress of Fossombrone in

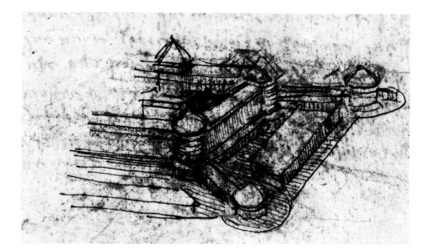

At the end of the 15th century, the rapid development and increasing power of firearms changed the principles of fortress building. Until the seventies, fortifications preferably had square turreted towers and high walls – as in the typical fortress shown on the opposite page, the Castello di Tor-rechiara, which is still standing near Parma. Then architects began building fortifications with rounded towers and thick inclined walls geared to the effect of heavy artillery, both offensive and defensive. Francesco di Giorgio Martini was one of the most renowned specialists in military architecture and engineering of his time. Leonardo – 13 years younger – had certainly learned a lot from him by exchanging views and experiences when they met and by studying Francesco's Treatise, *a copy of which Leonardo owned. He borrowed from Martini the idea for the sketch (Codex Madrid II, folio 79 recto) – a citadel that represented the transition to the low rounded bastion of later times.*

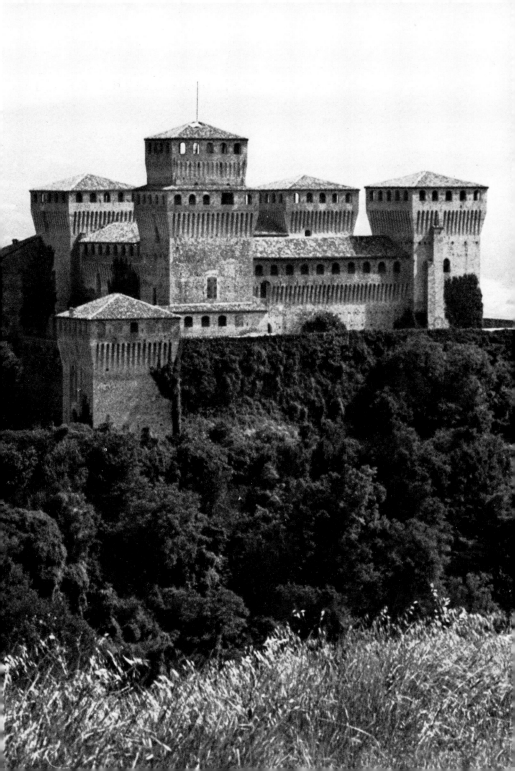

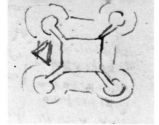

"At the strongest corners, towers should be placed, with lateral defenses, which defend the walls which contain the massive corners." MADRID II 92v

"The lord of the manor must be able to go through the entire fortress, including the upper, the middle and the lower parts, using tunnels and underground passages, which shall be disposed in such a way that none of them could be used to reach the dwelling of the lord, without his agreement. And through these ways using portcullis and other devices he must be able to imprison in their residence all those of his retinue, who may plot against him, and may close or open the door of the main entrance and the relief route. And this danger is even greater than the enemy itself because those on the inside have greater opportunity to do harm than the enemy who is shut out."
MADRID II 89v

"If a square tower is provided with pyramids at the corners, with varied shelters, like stairs, ports, double bridges, devious entrances, ravelins and ditches, it will have, by itself, great resistance." MADRID II 89r

Leonardo's top two sketches above deal with the placement of towers within the fortress. The bottom four relate to the shapes of the towers themselves. In the notes for these designs and the ones on the opposite page — some of them variations on the ideas of Francesco di Giorgio Martini — Leonardo provides precise specifications for moats, construction of towers, and the organization of firepower against the enemy outside the gates. But he is also at pains to contain the potential enemies within — see the transcription from Codex Madrid II, folio 89 verso, above.

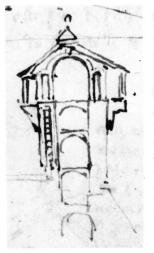

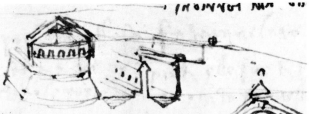

"*The secondary towers must be low and wide, covered by a vaulted and beveled roof, at a very obtuse angle, in order to deflect the transversal shots.*" MADRID II 93v

"*For defense against mortar-fire the tower should be built in such a way that the escarpment continues in straight lines that join at the summit of the tower.*" MADRID II 92v

"*Tower of bosses.*" MADRID II 93v

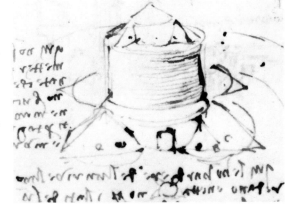

"*Here the embrasures of one ravelin overlook and protect the sides of the other ravelin. And so do reciprocally all the others. And here no scaling ladders can be planted.*" MADRID II 93r

"*If the fortress can be attacked only from a single side, make that side in the form of a massive acute angle, of 25 to 30 feet, with its lateral defenses. At this same side the doors should be located, with towers behind and shelters convenient to them.*" MADRID II 93r

October 1502, when Cesare Borgia's troops succeeded in penetrating the secret accesses to the citadel during the night through the use of the enemy password *Feltre*. It is evident that Leonardo considered every military aspect in carrying out these tasks. He examined traditional fighting and tactical methods of medieval warfare, as well as innovations in fortification technique that had resulted from the increasing use of firearms.

Thus, as we have been able to follow from his short stay in Piombino, Leonardo developed for Appiani a project of fortification which must have demanded a considerable length of time to execute. Only the remark "the moat which I am straightening" allows us to conjecture that the digging of the tunnel started during Leonardo's presence there. It would be important to ascertain, through a trial excavation of the citadel, if any traces of this secret connecting passage still exist.

A drawing in the Codex Atlanticus which is not by Leonardo's hand reproduces the fortification system of Piombino with relative precision (p. 59). Whether the

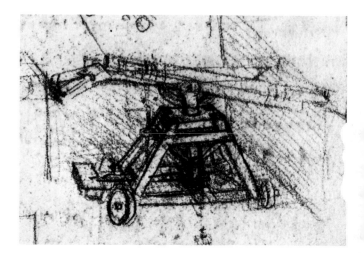

The plans for Piombino paid particular attention to a relatively new art – efficient organization of the firepower that was revolutionizing warfare. One of the chief functions of the soldiers in the old fortress towers had been to dump hot tar on assailants who tried to scale the towers with lad-ders. Leonardo was one of the first military architects to place a cannon in a tower, as in the sketch above from Codex Madrid II, folio 36 recto. In another sketch, from Codex Atlanticus, folio 48 recto-b (to the right), he plots the lines of fire from tower-mounted cannon.

artist was Antonio da Sangallo the Elder, as has been suggested, must be left undecided. Antonio had met Leonardo in the camp at Pisa, and it is therefore quite possible that Antonio, an equally respected military engineer of the city of Florence, had knowledge of the Piombino project. Only further research can now throw light on the defense installations of Piombino. Nevertheless, the extent to which Leonardo was engaged in this task – first in the service of Cesare Borgia, then later in that of Jacopo Appiani – is corroborated by further evidence in Codex Madrid II. A series of pages are crammed with extracts taken by Leonardo from the treatise on architecture by Francesco di Giorgio Martini. A detailed examination of these extracts shows that the choice of texts was determined by direct reference to the fortifications of Piombino. Most of the texts selected are connected with this specific task, and they may have served Leonardo for his "demonstration" before Jacopo Appiani, which we have to envisage as a complete exposition of his project. Of equal importance, the majority of the remaining extracts concern the construction of a tower of fortification, just as the tower takes up most room in Leonardo's draft of his plans for Piombino.

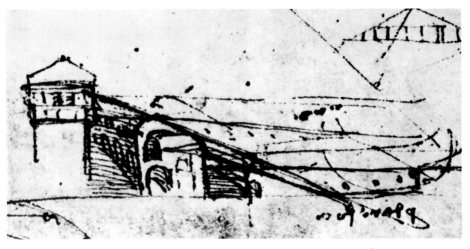

to open fire

Considering the aspect of the selection of Francesco's texts, it is of some consequence that two pages among them deal with the layout of a port. On one of these two pages is a small sketch of Leonardo's, accompanied by the note, "port of Piombino" (p. 57). It would seem that at the outset Leonardo sketched an ideal

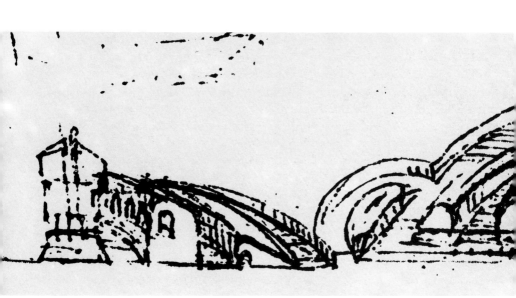

Out of his labors at Piombino Leonardo evolved a design for a fortress so different its like would not be seen for centuries. In his sketches above and below from the Codex Atlanticus, folio 48 recto-b, the first modern bastion begins to take form. Outposts on the four corners furnish flanking fire. Concentric fortified rings provide firing positions for the defenders of the citadel. Between the rings are trench-like areas that could be flooded if the enemy breached the outer walls, enabling the defenders to retreat to strongpoints in the innermost rings.

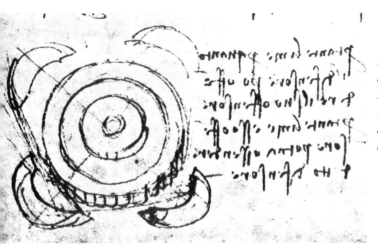

Along as many lines as the defender can strike at the offender, the offender will be able to strike at the defender.

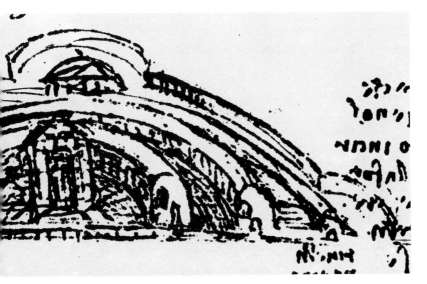

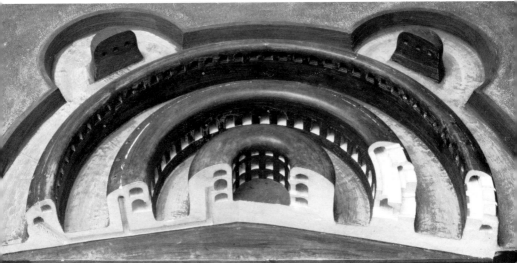

The cross-section model above of Leonardo's new fortress was built for the National Museum of Science and Technology in Milan from his designs in the Codex Atlanticus. His sketch below, in Atlanticus, folio 48 recto-a, shows a cross section of one of the tunnel-like fortification rings with portals for setting up fields of fire.

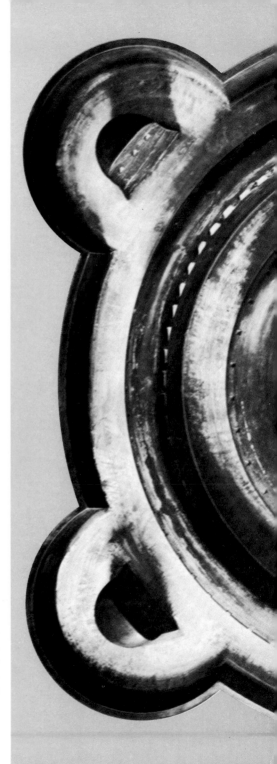

This composite photograph – making whole the semi-circular model shown on the previous page – shows Leonardo's concentric fortifications, each protected by a moat. The transition from the square ground plan of previous times to a completely circular fortress was thus (at least in theory) complete.

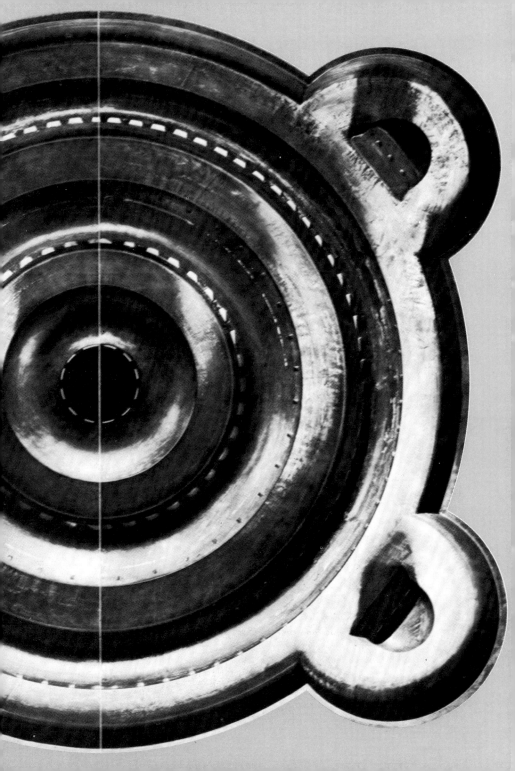

reconstruction of the ancient harbor of Piombino, even though it is a hasty jotting. Remains of the ancient mole, or foundation, can still be observed under water today, but it appears very probable that Leonardo had the intention of modifying the existing installation of his time, or that at least he toyed with the idea. The illustrations of certain appliances for construction under water assigned to Francesco's extracts differ substantially from Francesco's drawings, and they justify the conjecture that Leonardo sketched in here his own modifications. More than 10 years later he was again to take up a similar theme, when, during his sojourn in Rome between 1513 and 1516, he studied and reconstructed the ancient port of Civitavecchia.

All this collected material, written and drawn, which Codex Madrid II has to offer us on Leonardo's brief stay in Piombino provides a rare, living glimpse into the uncommonly versatile and quick powers of perception of Leonardo's eye and mind. When on the day of his arrival, November 1, 1504, he presents his plan of construction to the ruler of the city, when on the same day he stands down at the harbor and while contemplating the rigging of the fishing boats observes the interplay of colored shadows on the pale wall of a house – an image that charms his painter's eye and provokes reflections on the optical phenomenon – we can sense, as if we were standing beside him, the complete open-mindedness and vitality of his intellect.

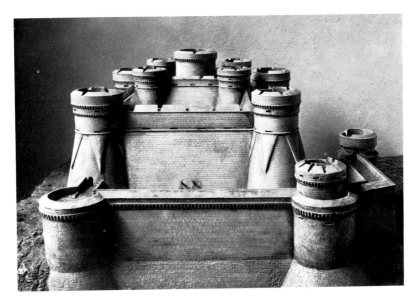

Leonardo's idea for a low rounded fortress represents a radical leap forward. Here the concept is contrasted with a typical design of his day. The model on this page has the turreted and slightly angled walls that characterized fortifications during the advent of heavy firepower.

Most dramatic of all is this side view of his fortress, whose ominous streamlined profile truly foreshadows fortifications of later centuries.

"The muscle power of the peasant, horse,
and ox were replaced,
under Leonardo's pen,
by wind and water, gunpowder and steam,
and as he matured,
the machine and its parts became
the language
of his involvement in the world."

MACHINES
AND
WEAPONRY

BERN DIBNER

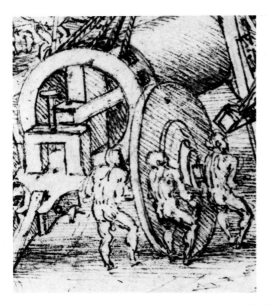

Nearly five centuries have passed since Leonardo recorded his thoughts and designs for machines and military matters in his several notebooks. This detail from a large sketch shows men mounting a huge cannon.

Leonardo was about 30 years old when he prepared the letter to Lodovico Sforza of Milan in which he offered his services and listed his many talents. His recital of some 36 abilities which were put at the disposal of the duke can be used as a measure of the interests of Leonardo at that time. Thirty of the claims are of a technical nature and six are in the field of art. The studio of Verrocchio, where Leonardo had worked, was decidedly non-military. One therefore concludes that Leonardo was drawn by the mechanical and engineering challenge that military devices offered – the challenge to extend the power of firearms and to develop new combinations of machines and weapons. One sees this interest in increased effectiveness of the machine in his note, "Instrumental and mechanical science is the noblest and above all others the most useful, seeing that by means of it all animated bodies which have movement perform all their action; and the origin of these movements is at the center of their gravity. . . ." [1]

Leonardo's dedication to the devices created by the mechanical arts can only be explained as his natural response to the benefits that come with their use, the constancy of the natural laws that control their operation, and the invariable

honesty of their behavior. Unlike the men and women about him, they performed their work free of emotion, vanity, or influence. He was intent upon discovering universal laws by experimenting with basic machine elements and assigning quantitative values wherever he could.

Having visualized a mechanical solution to a problem, he sketched the parts and the assembly, noted the working directions, assigned to himself further tasks for study, and moved on to other problems. Yet no solution was ever adequate, for he would return later to some similar device to accomplish the

same task by using different parts or a different assembly of parts. Consider, for instance, his concern with ways of converting reciprocating to rotary motion, a basic need in all machinery design. Leonardo sketched dozens of devices to accomplish this, never satisfied that he had attained *the* solution.

It was as a designer of machines and weapons for use on land that Leonardo prepared his widest variety of novel devices and left a heritage of drawings on military subjects unmatched in the rich history of this destructive profession.

He lived in the age of transition when massed armies of crossbowmen and mounted, armored troops were giving way to fusiliers and cannoneers. With this change in Western society came social and political changes the impress of which has reached into the 20th century. The simpler tools and implements of Leonardo's day evolved into the myriad inventions that had germinated in his mind. The muscle power of the peasant, horse, and ox were replaced, under Leonardo's pen, by wind and water, gunpowder and steam. And as he matured, the machine and its parts became the language of his involvement in the world. Yet the transition of Leonardo the artist to Leonardo the technologist

The flowering of the Renaissance had little direct influence on the people whose bread had to be earned by their own hands. The aristocracy scorned manual labor and those who practiced it. Even the artists ignored working people, preferring to depict the lives of saints, angels, madonnas, and dukes. One significant exception was Leonardo, who sketched a number of scenes, like the ones shown here, of farmers and laborers at work. His painting and studies in anatomy had led him to close observation of the human figure in all its forms. But as an engineer he had to study the particulars of manual labor like a modern time-and-motion expert: his notebooks show him calculating in precise detail the man-hours and labor costs for such complex projects as the diversion of the Arno. Increasingly, he focused his imagination, technical know-how, and passion for invention on what was to become the principal task of the modern era: designing machines that would multiply manyfold the frail physical efforts of man.

was not fully accepted even by some historians in our own time. It required the rediscovery of Leonardo's two codices in Madrid in 1967 to confirm that the prime interest of his mature years was engines, devices, and things of the material world of man the maker.

Nine-tenths of the Madrid Codices are devoted to technological subjects; they supplement Leonardo's other mechanical studies and provide the scholar of today with the most comprehensive corpus of Renaissance technology. It was

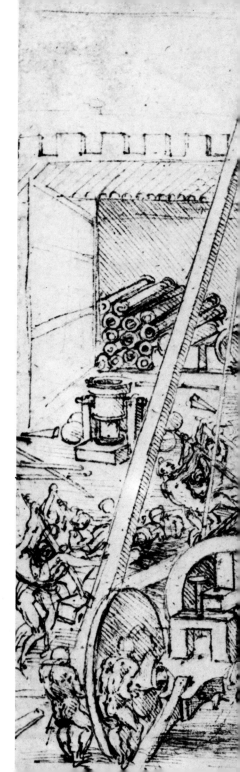

Leonardo's drawing of a foundry court-yard (opposite page) depicts the enormous difficulty of mounting a cannon with the crude mechanisms then available for increasing muscle power. In the center nude men push the huge gun carriage under the cannon while others strain at the levers of the crane to raise the cannon. In the foreground is the cradle on rollers by which the cannon was brought in. When this drawing was made, about 1487, Leonardo was engaged in the founding of bronze cannon for Lodovico Sforza. He haunted the forges and foundries of Milan, but cannon were not his consuming interest. He was looking for better ways to cast his great horse monument. A few years later, of course, all the bronze earmarked for that epic project — Leonardo's grandiose dream — was to be poured into the casting of more gun barrels.

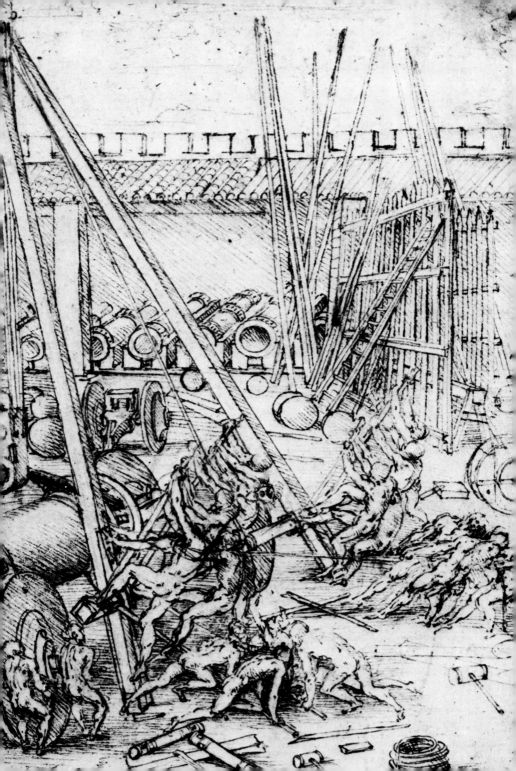

the technicians who gleaned most from the new material, because Madrid I is almost solidly mechanics- and technology-oriented, while Madrid II contains much in geometry, mechanics, navigation, and topology.

On examining the hundreds of Leonardo's mechanical designs,[2] one sees in them attempts to combine motions and incorporate them into a machine to attain automated action. This was definitely an order of attainment above the results obtained from the classic mechanisms. The concept of automation is not related to complexity but to feedback. There is a dependence of one mechanical operation on another, which eliminates the need for a decision to perform the second operation after the first is completed; the sequence of actions is designed into the mechanism. Leonardo derived obvious satisfaction from creating such multiple designs, and a representative selection of them has been made here to illustrate his genius in conceiving them and then drawing them vividly in perspective. Those selected indicate Leonardo's advanced acquaintance with the language of gears, pulleys, ratchets, cams, wedges, linkages, cranks, and racks and pinions. To them he brought a background of contact with field and shop and a grasp of fundamental physics and chemistry.

To interpret Leonardo's drawings, one usually begins with the point of application of the motive power – the crank. Though power in Leonardo's day was muscle power, derived from man or animal, where great power was required he resorted to the energy of falling water or to wind power. He also knew about the storing of power in springs and raised water and the inertia of flywheels. To speculate on what Leonardo might have accomplished with the availability of other energy sources is pointless.

Leonardo's machines were intended to be applied to general use in industry – hammering, shaping wood, stone, and metal, raising great weights, casting metal, drawing strip and wire, weaving textiles, coining, grinding, digging canals, turning, winding, lifting, moving – the basic needs of any urban society. As intriguing as the machines were to Leonardo, one sees among his drawings his concern with multiple solutions to the problem of transfer of forces – concern, that is, with the spirit of the mechanism rather than its specific parts. What was its purpose? How might it best operate? How else might it be structured? Could it be made simpler, faster, more useful? Could steps be combined?

An inventory of Leonardo's machines divides them into the major categories

In his famous letter to Lodovico Sforza, Leonardo had promised new and secret instruments of war. He sketched the technique shown in the drawing below – a warrior's hand-borne lance is augmented by two others affixed to his horse's saddle – only a year or so after his arrival at the Sforza court in Milan. The tripling of the rider's lance power must have appealed to Leonardo's penchant for designs that multiplied a simple force, but he probably borrowed the basic idea from accounts of ancient warfare. He had a magpie mind that picked up ideas everywhere – from the books of others, from the tales of travelers to distant lands – ideas he then improved and made his own.

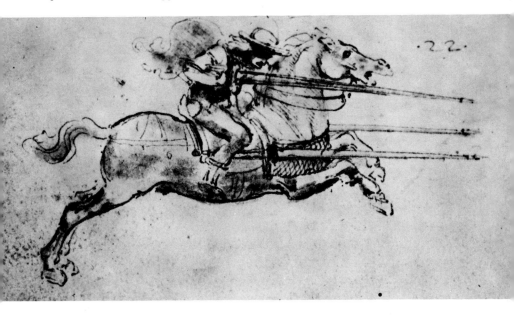

of those for improving mechanical work (and therefore productive) and those for military application (and therefore destructive). The cities of Florence, Milan, and Venice were then among the most active in establishing patterns for mills, pumps, winches, wagons, tools, and the weapons of war, and the design of these intrigued Leonardo. He haunted the wrights and masters of forge and mill to observe design change and progress and to record them in his notebooks.

Beyond the general categories of civilian and military application, Leonardo's designs do not lend themselves readily to rational subdivision, since he usually followed the sketch for one device with another unrelated one. Let us therefore choose some readily distinguishable device, focusing on its ingenuity of design, and then move on to others.

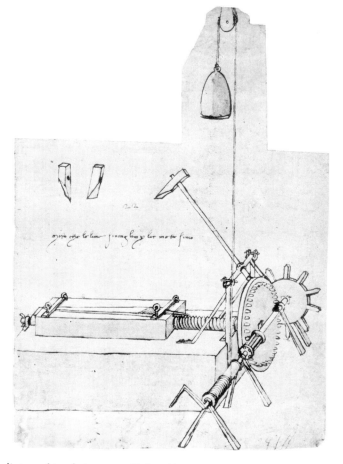

One of Leonardo's earliest machine designs, the elegantly rendered file maker (above) from Codex Atlanticus, folio 6 recto, reflects his intuitive grasp of the modern concept of automation. He builds into the mechanism a sequence of co-ordinated and interdependent actions that, once started, do not require further human decision.

Right: About 1495, in Atlanticus, folio 21 recto-a, Leonardo incorporated the same advantages into the mechanism at right, which automatically stamps gold foil used for decorative purposes. The assembly view, at the top left of the drawing, shows the six stamping units that are activated by a master crown gear.

Let us examine a machine for making a tool almost as common as the hammer and used for shaping wood, metal, or stone – the rasp, or file. It is very easy to use but difficult to fashion. As with so many other efficient tools, higher skills go into their fabrication than are required for their use. Leonardo approached the solution to the file-making problem by designing a machine to strike file teeth evenly on the face of a metal blank, which could afterwards be hardened by the tempering methods then known to craftsmen (above).

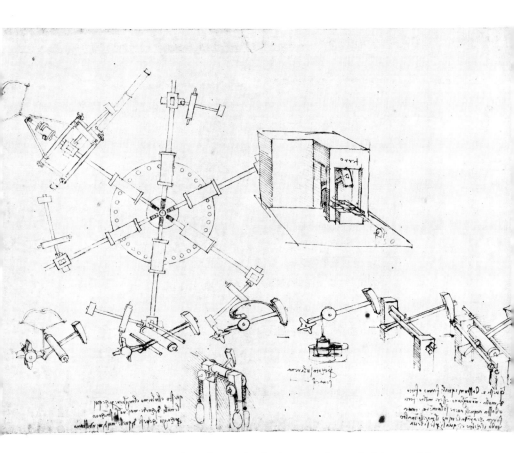

The result of the automated and interlocked operation of this machine is a quickly executed file face of uniform grooves. When the weight's descent is completed, the hammer is raised to disjoin lug and sprocket, the crank again raises the weight, and the indenting of the grooves on the file's face is continued. At the left of his drawing of the machine – one of Leonardo's very early drawings, dated by G. Calvi at about 1480 – Leonardo sketched two different hammer heads with which to cut grooves with other angles or to produce cross-cut grooves. In its simplicity and elegance the line and wash rendering of the drawing makes it as ready a guide to the construction of the machine as to its understanding.

With the same need for transferring individual skills into devices that would provide greater uniformity of product and higher output per operator (at lower cost per unit produced), Leonardo designed a machine for the automatic stamping

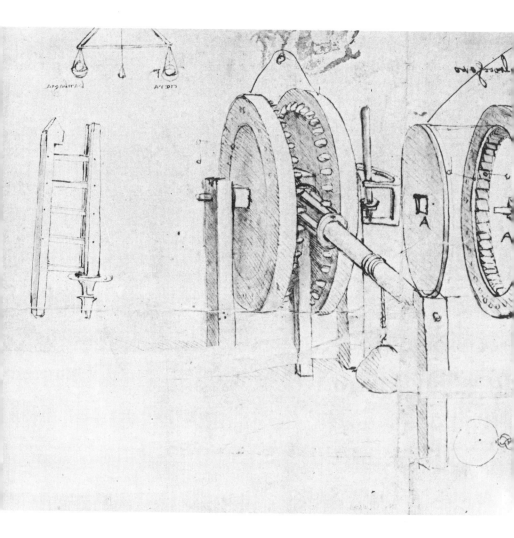

of gold foil. The assembly indicates a plan for six units motivated by a master crown gear turned by some prime mover, such as a water mill or an animal (p. 81).

Turning from utilitarian designs to the more abstract, Leonardo sketched a brilliant resolution to the problem of translating rotary to reciprocating motion, or vice versa. The illustration is so clear and instructive that it hardly requires explanation (above).

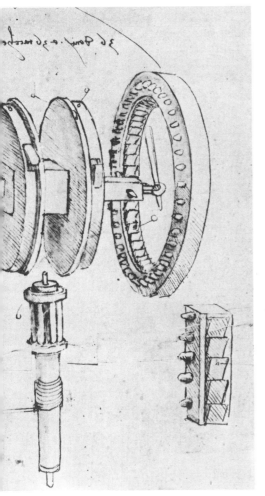

Leonardo sketched dozens of devices aimed at translating movement back and forth between rotary motion and piston-like reciprocating action. The drawing (left) of a windlass to be used for hoisting heavy loads is so exacting and finely detailed as to be the envy of a 20th-century engineering draftsman. The assembly view is at left, the exploded view at right. The weight to be lifted can be seen hanging from the lantern gear. Motion begins when the operator manipulates back and forth the vertical lever which is set into a square shaft at the right of the assembly view. His reciprocating motion activates the system built into the wheels and shown in the exploded view. Pawls on the two inner discs engage ratchets that line the two outer rings. Gear teeth on the same outer rings engage the common lantern gear at the end of the shaft holding the weight. When the vertical lever is moved forward, one pawl moves one gear. When the lever is moved back, the other pawl grips the gear and turns the shaft. No matter which gear is activated, the lantern gear is moved constantly counterclockwise and the weight is lifted.

This ingenious mechanism can be used as a windlass or a hoist or in several schemes Leonardo had for automotive vehicles. One application of the mechanism that was sketched by Leonardo is for the propulsion of a boat (p. 84). Another application is suggested by Leonardo in a Codex Madrid I drawing of a foot-operated grain mill (p. 84, bottom).

Yet another of the many studies of the reciprocating-to-rotary-motion problem that occupied Leonardo's mind has a solution drawn in about 1495, in Codex Madrid I (p. 85, top).[3]

Leonardo lived in a restless period in the history of Europe, an age much like our own. His birth coincided with the Gutenberg invention, one of the most revolutionary developments in all human history. This was an appropriate time and place for the innovative mechanical genius of this master of technology to be exercised. His drawings record the creations of a most fertile mind and help define the status of the mechanical arts of the last quarter of the 1400s.

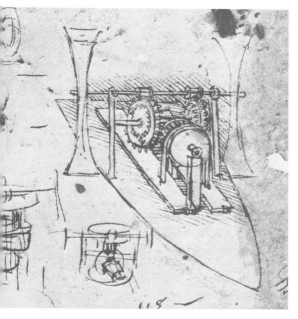

Here, a boat with vertical paddles is propelled by the same system used to operate the windlass on the preceding page. The paddles are turned by treadles which are moved up and down by a mechanism similar to that of the windlass.

A foot-operated grain mill (below) is another version of the windlass proposal. Pumping the treadles seen in the assembly view at center sets the levers into alternate motion, making the central shaft revolve and, through the crown gear, turn the millstone.

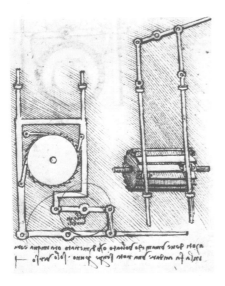

The two sketches here, intended as studies on the reciprocating-to-rotary motion problem, propose another solution. The lever in the right-hand design is pumped up and down while the pawls on the vertical rods engage the ratchets on the cylinder. On the downbeat, the pawls slide past the ratchets; on the upbeat, they engage the ratchets and turn the cylinder.

The machine below looks remarkably like a modern lathe and is often mistaken for one. Actually, its function is to bore holes in the centers of logs, which were used as water mains until cast-iron pipes took their place late in the 17th century. The drilling mechanism is in the foreground, but the novel aspect is the set of automatically adjustable chucks shown clamping the log in the four radial positions. The chucks ensure that the axis of the log always remains in the center of the machine regardless of the log's diameter.

In the wood planer sketched below, Leonardo makes use of a set of adjustable clamps similar in concept to that employed in the boring device at left. The main sketch shows the facing jaws that open or close according to the size of the log being planed. Their simultaneous action is regulated by a cord wrapped around the capstan in the foreground. A set of threaded nuts raises the timber to permit the plane to trim the top surface.

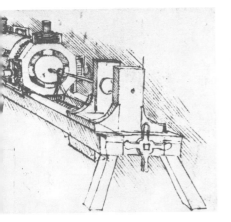

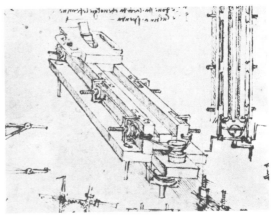

Leonardo's notebooks often read like a modern mail-order catalogue that offers an ingenious tool or gadget for every conceivable purpose. The device below mechanizes the primitive techniques then used for forming wire by pulling it through dies. The main view, a cross section, shows the large crank-operated bolt which ends in a hook-and-eye fitted over the handles of tongs. The tongs clasp the strip of wire (sketches below and at right of main view) so that the stronger the pull, the tighter the grip on the wire. The crank, at top left, is encased in a loose sleeve to afford the operator a more effective grip. The vertical threaded bolt in the right part of the main view adjusts the dies to proper spacing. Additional dies in horizontal and vertical positions are at the right of the drawing. Ball bearings reduce the friction between the two discs, top left.

86

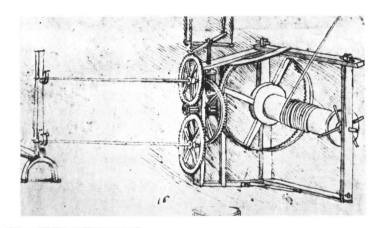

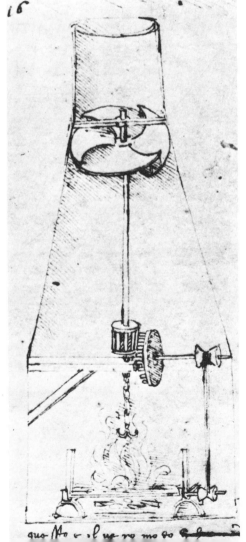

Leonardo became aware very early of the power inherent in the harnessing of heated air. Like an ingenious home handyman, he put his discovery to practical use in the kitchen. The roasting device (left), which was drawn about 1480 in one of his earliest technical studies, utilizes the heat of the fire to turn the meat automatically. At a time when nearly all cooking was done over an open fire, Leonardo's design not only promised to liberate the cook but provided evidence of the first known use of a true air-screw. The upwards draft of hot air turns the vaned turbine set in the chimney. The turbine is geared to a pulley arrangement which turns the spit. "The roast will turn slow or fast depending on whether the fire is small or strong," noted Leonardo. He sketched on the same page of the Codex Atlanticus, folio 5 verso-a, another mechanical spit (above, right) powered in less imaginative fashion – by a descending weight attached to a pulley-and-gear drive.

87

As a young man Leonardo learned the textile craft in Florence, then a mecca for those seeking fine cloth, and he later sketched scores of improvements. The design below ensures the even winding of thread onto a bobbin. The intricate winding mechanism is shown in detail in another illustration (below, right). The top sketch is an assembly view; below it is an exploded view. As the crank turns the main shaft of the mechanism, the con-

necting rod moves the bobbin axially in and out of the hollow shaft, enabling the thread to be wound uniformly on the bobbin's cylindrical face. Leonardo also designed a number of mechanical looms and a needle-sharpening machine that he calculated in the Codex Atlanticus would earn him 60,000 ducats a year – a princely income that apparently never materialized.

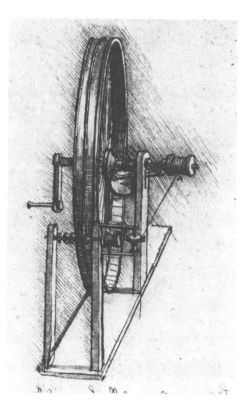

About 1495 Leonardo invented the shearing machine (right) to cut the nap off woolen cloth – a process then carried out by shearmen with enormous scissors who had to crop the nap like a barber. In Leonardo's design the cloth was stretched on a traveling frame which was pulled through the machine. The gearwork activated the second blades of

scissor-like devices. Leonardo also devised a machine, called a gig mill, for raising the nap on woolen cloth. His gig mill and its successors were so efficient that they put manual laborers out of work; early in the Industrial Revolution widespread use of the gig mill caused riots in England.

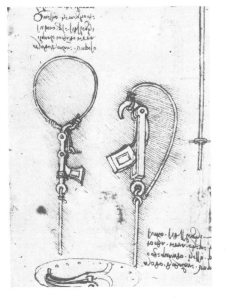

Leonardo, who was born about the same time Gutenberg invented the printing press, proposed the device below for repositioning the press mechanically after an impression had been made. He also anticipated modern engraving methods with a process using copper plates etched in relief, which would have allowed much finer reproduction of his intricate drawings than the woodcuts then in use. In fact, though Italy was the printing center of Europe, none of the treatises that Leonardo intended to publish was printed until 132 years after his death. In 1651 an abstract of his notes on painting was published in Paris.

The devices above, from Codex Madrid I, are release mechanisms for automatically releasing a load when it reaches the bottom of its descent. The hooked weight on each device is kept in position by the tension of the load. When the cargo reaches bottom and tension eases, the weight pivots downwards, uncoupling the hook.

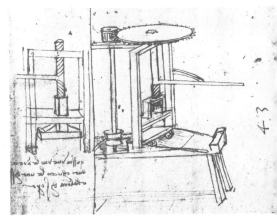

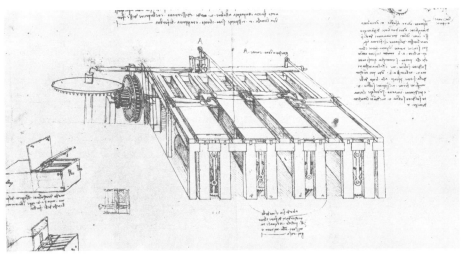

Some of the elements of the preceding machines are contained in an advanced mechanism for grinding an internal cylindrical bore such as might be required for a bearing – a grinding and lapping device (p. 91). Leonardo sketched the rough cylinder clamped by two hollow vise jaws held firm by adjusting wing nuts (which, to produce pressure, should have been on the inside of the studs). The reamer, or lapper, extends partway into the bore. Grooves are cut into the outer surface of the reamer to hold the polishing, or lapping, compound of oil and emery. The top of the reamer rises through a complex and ingenious mechanism consisting of a spur gear, as seen, having an internal thread of high pitch. Into this thread is fitted a bolt having the matching outer pitch and a rectangular inner bore. The gear is confined by the two horizontal plates so it can revolve but not move vertically. The threaded bolt rides up and down within the gear as it turns, because it is confined by the rectangular inner shank. The circular plate has a semicircle of gear teeth that engage the horizontal gear. At the extreme left is a vertical spring rod. From the top of this rod a string passes through the stud and is wound upon a collar extending above the gear. The device is now ready to lap the cylinder bore. The large disc is turned, the teeth engage the gear, it revolves and so causes the bolt to turn and descend into the bore. But the disc teeth and the gear become disengaged at the half-revolution. The spring takes over and the taut string unwinds, causing the gear motion to reverse and the bolt to ascend, thereby reversing the polishing motion. The top is reached, the disc teeth engage once more, and the cycle is repeated as long as the disc is revolved. The reamer thus turns and reverses as it moves up and down.[4] Excess lapping compound drips into the small dish beneath the bore.

The bent of Leonardo's mind and his efforts to automate as many coacting motions as possible are evident in this assembly. That there existed a practical application of such a device is evident from the growing number and variety of machines then being used. Boring devices were required for pumps and cylinders, for mills, locks, ships' gear, hydraulic fittings, valves for liquors and for cannon and other armaments. Close tolerances were required for the meshing of gears and for accurate bearings, and Leonardo was aware that a mechanized means of bearing fabrication was superior to a manual one.

The mechanism at right was designed to grind and polish the insides of cylinders.

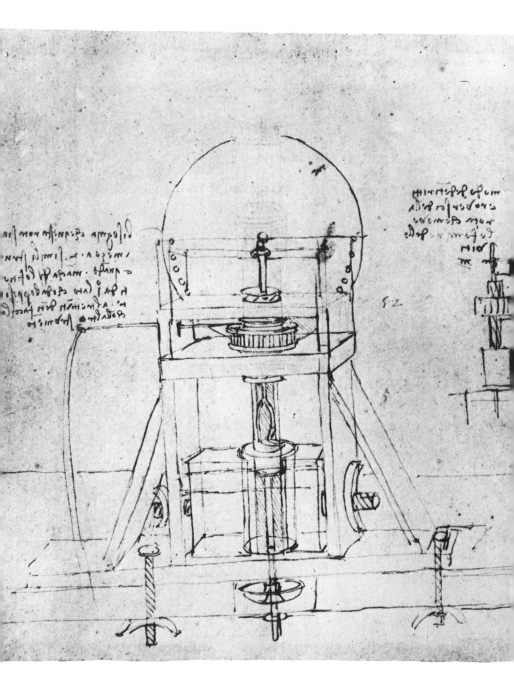

91

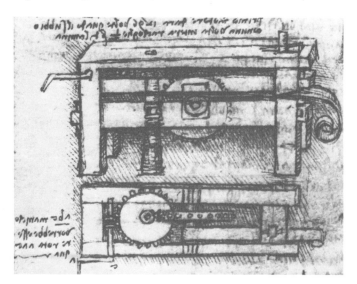

Leonardo foresaw the need for standardization of metal parts for machines and he fathered a large family of metal-fashioning devices. He drew the design above, a metal roller for turning out tin sheets, about 1497. It has a simple feature that scholars believe to be a first in the history of technology: two small pressure rollers that prevent the main rollers from bowing at the center, thus assuring a smooth, flat sheet of even cross section.

Late in life, about 1515, Leonardo designed the mechanism below for making bands of copper. The device is seen from the side at the top of the drawing, from above in the lower part. It consists of a bench with a crank and worm gear which turn a horizontal gear with iron teeth.

That Leonardo was a journeyman's engineer and not an impractical dreamer is evident from his concern with the basic materials from which tools and engines were wrought. To build machines, a wright must have metal bands and plates, facilities for casting odd shapes, and tools for cutting, bending, twisting, and turning coarse and fine metal sections. Leonardo knew that after rough fashioning surfaces had to be prepared, ground, fitted, or polished. With increased industrialization an increase in standardization became mandatory, as well as a higher availability of cutting and shaping materials and tools and their greater mechanization. We shall therefore examine some of the devices that Leonardo designed to fashion metal sections by employing advance machines for converting simple motion and limited energy into uniform and required basic shapes of metal and wood.

One among a large family of metal-fashioning machines is an assembly of rollers for producing flat tin sheets that Leonardo drew (left). The assembly is indicated in a bottom sketch that shows a crank-operated gear of small diameter acting on a large gear so as to provide a high mechanical advantage, since metal rolling is a very difficult task. The arrangement is elementary but Leonardo has added a significant touch, in an upper sketch. Realizing that the enormous stresses of this method of moving metal would cause a roller of any sturdiness to bow at its center (resulting in a convex section of rolled plate), he has added two pressure idlers, one at the center of the top roller and a corresponding one on the lower roller. These secondary rollers would reduce the diverging thrust at the main rollers' centers and give a more uniform cross section to the rolled plate. Simple as the rollers appear, they are considered by Feldhaus [5] to be the earliest known to historians of technology. They were drawn about 1497.

Leonardo revealed more of the thoughts he contributed to the rolling of metals in illustrating an assembly for drawing bands of copper (left). Designed rather late (about 1515) it consists of a bench with a crank and worm gear slowly turning a horizontal spur gear having iron teeth. The gear's shaft has a second worm on it and this meshes with a vertical gear. Integral to the shaft of this gear is a cylinder on which the drawn coil of copper strip is wound. The drawing dies are shown at the right in Leonardo's plan view; a driven wedge controls the pressure of the upper die. The drawing of the plan view (from above the assembly) should have been placed above, not below, the elevation view (from the side).

For many people today all aspects of war arouse a negative feeling, a revulsion brought on by the excesses of four major wars in a century still only two-thirds over. A document such as the Madrid manuscripts therefore provides a measure of historical change and of the relationship of an unusual mind to its times. Leonardo hated war as strongly as any rational person has ever hated it, calling it "beastly madness"; but living in the unsettled condition of northern Italy at the end of the 1400s, he was exposed to the demands of incessant war and the sweep of invading armies against his people in Tuscany and Lombardy.

Leonardo served three lords in some military advisory capacity, displaying a continual interest in the design and technology of military structures and weapons rather than battlefield tactics and maneuvers.

The design of Leonardo's weapons falls into three general categories: ballista (catapult), cannon, and arquebus (musket). The ballista was of classical origin. Leonardo derived much of his mechanical and military information from reading the references in technological texts in contemporary military literature and from his contact with military men who, like himself, were in the employ of the Duke of Milan. Through his father, Ser Piero da Vinci, notary to the governing council of Florence, he had contact with the military men of that strong city-state. From reading the works of Archimedes, Pliny, and especially Vitruvius, he learned the military methods and technology of the Roman period. Among his contemporaries, he was influenced by Francesco di Giorgio Martini [6] and by Roberto Valturio, whose book *De re militari* was published first in 1472 and again in 1483. An older variation on his work is that of Flavius Vegetius, a Roman writer whose treatise on military tactics was reissued through the centuries and constantly modernized. Both books were illustrated by crude, naïve, anachronistic woodcuts, in contrast to the clear, striking draftsmanship of Leonardo.

One of Leonardo's most famous drawings is that of a huge ballista shown with some advanced features of design; the drawing is so skillful as to make it a classic of graphic representation in engineering (96–97). Leonardo indicated the great bow in laminated sections for maximum flexibility. The bowstring is drawn back by the worm and the gear shown in the lower right corner. Two releasing trips are shown, at lower left. The upper is spring-pivoted and released by a hammer blow; the lower is tripped by lever action. The bowman, as shown in the main view, bears down on the bar and, by lifting the encased

lever, releases the string. The wheels are canted to give them a wider, more stable base and also to reduce road shock. A similar means was later used in canting the spokes of most artillery wheels.

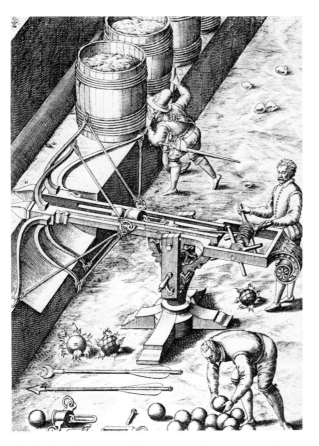

Until the refinement of the cannon, the principal artillery weapon was the catapult or ballista – as the larger models, such as Leonardo's on the next page, were called. The print above showing a ballista and the explosive shot that the weapon's multiple bows could fling at the enemy is from a copper engraving made in 1588. Similar devices, capable of hurling oversized lances and huge stones, were used 15 centuries earlier by the Roman legions, who called their deadly ballista "scorpion."

Overleaf:
Leonardo's concept of a big ballista was classically drawn and so enormous that it dwarfed the bowman who had to trigger it. The huge bow is built with laminated sections for greater flexibility and firepower. more stable firing base, a feature later incorporated in the wheels of artillery pieces. Two versions of tripping mechanisms are shown at left.

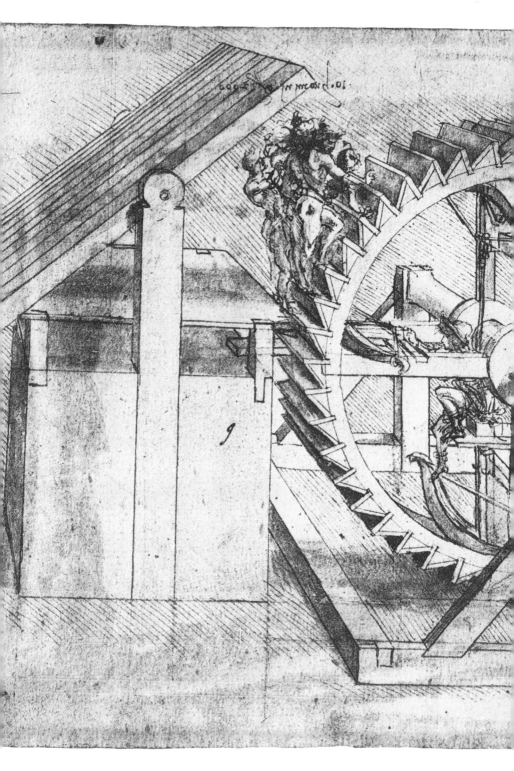

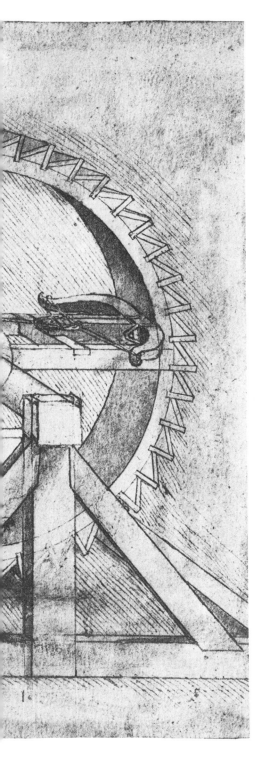

This delightful contraption is a kind of crossbow, a machine gun that enables Leonardo's archer – suspended inside the big treadwheel – to keep the arrows flying at a rapid pace. The archer's comrades furnish the foot power to turn the wheel under the protection of a planked shield Leonardo has provided for them.

Make the stem, which gathers the rope charging the crossbow, ⅓ thick, so that a turn gathers one ell of rope. So, since the above-named stem is one third, its half will be one sixth, and the lever is five ells, that is, 30 sixths; and one sixth is the counter lever, so that you have here 30 against 1. Therefore it appears clear that if you place over the head of the lever 20 men weighing 4,000 pounds, they will exert against the counter lever a force of 120,000 pounds, enough to charge the 4 crossbows.

A rapid-fire crossbow mechanism is as impressive in design as it is in its illustration by Leonardo (pp. 98–99). Tension is given to the strings of each of four bows mounted on the inner periphery of a large treadwheel. The treadwheel is rotated on a horizontal axle by a team of men who walk on a circumference of outer treads and thereby provide continuous rotation for rapid fire. An archer hangs suspended in the mechanism's center; his task is to trigger each crossbow as it descends the quadrant before him, shooting through the slot in the structure at left. The main axle is not rotative and could therefore be fitted with lines and hooks for drawing each bowstring back as the bow is rotated into firing position. A board is shown protruding into the firing line, indicating Leonardo's intention to hold the wheel for a proper aiming interval. Also noteworthy is the heavy, pivoted baffle of planks to protect the treaders. Leonardo places the treaders on the outer periphery of the rim (rather than on the inner rim, as was then customary) for greater leverage and efficiency. The drawing combines signs of hasty overdrawing of lines and circles with precise mortising of joists and braces, exact planking of the treads, and the long and precise shading lines of a left-hander, applied not to the object but to the background so as to accentuate the machine. To the right of the main design is a preliminary sketch showing the operators in dynamic activity.

This preliminary sketch of the automated crossbow shows wheel and bowmen in whirling action. In Codex Atlanticus it appears alongside the main design.

Many other of Leonardo's sketches show ballistas and catapults using the energy stored in bent and twisted wooden arms, in metal springs, and in the torque of ropes twisted by the use of worms and gears or racks and pinions. Many of these designs appear in older sources, for Leonardo transferred to his notebooks any that were of interest to him.

The firepower of guns and artillery continually engaged Leonardo, and some of his finest studies concerned them. It was 150 years after that fateful day at Crécy in 1346 when two cannons attended by 12 English cannoneers first fired a shot propelled by gunpowder at an enemy in battle. Yet a casual examination of some of Leonardo's sketches would indicate that his techniques were those of an artillerist of the mid-1800s. In some respects he was ahead of even those days. He was, for instance, concerned with good shrapnel[7] design, with breech instead of muzzle loading, with ease and speed of fire, with multiple fire, and with advanced gun-construction methods, including water cooling of gun barrels. Leonardo proposed setting the barrel of one breech-loading gun into a sealed copper casing filled with water "in order that once fired, the copper soon abandons its heat." This water-cooled gun fired iron-tipped bolts, and Leonardo called it *fulminaria* because of its lightning fury (below).

In Codex Madrid I there are more than a dozen notes and diagrams related to matters of arms and ordnance. These are essentially probes into the theoretical action of stressed crossbows and the behavior of discharged bolts; but, more interesting, two of the notes pertain to the coupling of rockets with balls fired from cannon. In the crossbow series[8] Leonardo attempted to relate bow tension to the range of the arrow, reminding the reader to allow for air resistance. On folio 59 he described an elaborate series of tests of crossbow effectiveness carried out by gauging the vertical rise of a weighted, graduated, and iron-pointed arrow and enabling it to register its penetration into the test-range soil (p. 104). He concluded that the indicated depth of penetration was in direct proportion to the arrow's vertical rise and to the order of tension given the bowstring, as measured by increasing weights. Leonardo used weights as the measure of the input force and held gravity and the vertical trajectory as constant. It was Leonardo who confirmed the notion that an arrow shot vertically into the air will fall vertically downwards.[9] He followed the precepts of Albert of Saxony in describing the trajectory of a missile and was the earliest to draw the trajectory as a continuous curve.

The more revealing concern of Leonardo with ballistics is shown on folio

Opposite:
In a day when the use of long-range firearms was still relatively new, Leonardo advanced such modern notions as a water-cooled gun barrel. The barrel of the gun above is breech-loading – itself a novelty. In the bottom sketch it is set in a copper casing filled with water "in order that once fired," writes Leonardo, "the copper soon abandons its heat."

Above:
This deadly looking, dart-like missile is an early form of the high-explosive artillery shell. Leonardo meant for this, and a similar projectile that he designed for Lodovico Sforza, to be fired from a catapult. The two fins jutting back from the pointed nose – Leonardo calls them horns – contain powder which ignites upon impact.

58 verso, where he proposed the vertical firing of two balls (separated by equal gunpowder charges between the breech, the lower ball, and the upper ball) from the bore of the same cannon. He described the simultaneous discharge, the top ball clearing the muzzle for the second ball, but he held that the first (top) ball would rise higher, having been assisted by the second ball's charge in addition to its own charge. He then introduced the factors of help or hindrance of distance, sound, flash, and impact due to the direction of the wind on a projectile. Firing in foggy air will result in a louder burst, as also will firing against a water surface or against a wall. In vertical firing, Leonardo said, "the cannonball moving upwards – be it because of the assistance of the upwards-moving flame or because the air becomes thinner and less resistant as the height increases – the ball will have the greatest accidental motion among all other possible directions." [10]

Leonardo made these sketches of crossbows in Codex Madrid I as he recorded a series of ballistics tests that are remarkable as examples of his experimental method. "Test it first and state the rule afterward," he cautions in a note over one sketch (above).

Opposite page:
In the margin of the page, he states one of his "rules": "The length of the arrows' descent will be proportional to the weights used in the spanning of the crossbow."

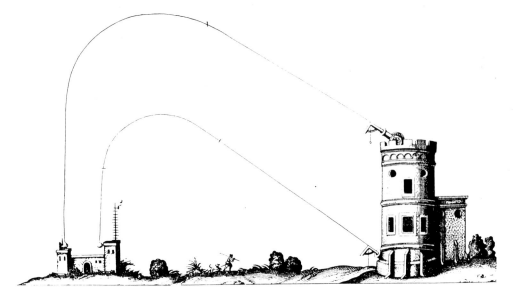

In a note on folio 59 verso Leonardo revealed his design for the simultaneous firing of a shaft and a rocket in order to attain a great height – a mile or more. The project involved pointing an arquebus vertically, with shaft and rocket of equal weight. Leonardo proposed that the rocket be ignited first, or that the rocket fire ignite the powder in the gun.

An expansion of this project is indicated by Leonardo on folio number 81 verso. He wrote, "To fire a rocket to great altitude, proceed this way: Set your cannon upright, as you see; load the cannon with a ball connected to a rocket by a chain, leaving the rocket on the outside, as shown by the figure. Then secure a small board, with gunpowder, level with the touchhole of the cannon. Having done this, fire the rocket, and the rocket's fire, falling on the board and the touchhole, will fire the cannon. The cannonball will drive the rocket more than 3 miles high and a flame half a mile long will be seen trailing the rocket." Here again, the coupling of rocket to cannonball is intended to reach unusually high altitudes.

Obviously Leonardo speculated about (or experimented with) these projects for no direct military purposes, since no target existed in vertical space. It can therefore be taken that these were exercises in novel ballistic combinations, with methods already provided to measure range by soil penetration. For the

The trajectory of a cannonball, it was believed, formed two straight lines connected by a short curve – as in the drawing at left from a military treatise published in 1613. Though this erroneous notion prevailed until the late 17th century, Leonardo already had correctly drawn in Codex Madrid I, folio 147 recto (right), the proper parabolic curve deformed by air resistance.

heading on one folio showing some of this investigation, 51 recto, Leonardo wrote, "Test it first and state the rule afterward."

He explained dynamic phenomena on the theory of "impetus," which meant to him that a moving body continued motion in a straight line. But he did not adhere to the view of Albert of Saxony that the trajectory of a projectile was divided into three periods: the initial violent impetus; the secondary period, in which gravity begins to act; and the tertiary, in which gravity and air resistance dominate over the impressed impetus.[11] The Italian mathematician Niccolò Tartaglia still followed this traditional belief in his first book (1537);[12] in a second book, written almost 10 years later,[13] he took up the subject again, arriving at the timid conclusion that no part of a trajectory can be perfectly rectilinear. But we are still far from the parabolic trajectories traced by Galileo and calculated mathematically by Newton (1687).

The fact is that up to the late 17th century all military treatises dealing with artillery still depict the trajectory of a cannonball in the form of two straight lines, the second perfectly vertical, united by a short curved section (p. 106).

Leonardo could not develop mathematical ballistics. But his unerring eye saw the truth, and his precise pen put the correct curve, a parabola deformed by air resistance, into many illustrations – in Codex Madrid I, for instance, when he was developing his theory about accidental and natural movements, comparing pendular motion with that of a projectile (p. 107). The same reasoning was done by Galileo in 1632.

Leonardo sensed the increase of air resistance to a projectile with the increase of the projectile's velocity, without determining the exact ratio of this increase. "The air becomes denser before bodies that penetrate it swiftly, acquiring so more or less density as the speed is of greater or lesser fury."[14] In spite

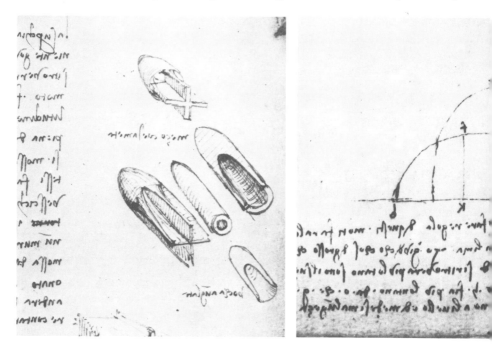

Leonardo was unable to arrive at a mathematical solution to the trajectory problem – that had to wait for Isaac Newton in 1687. Nor did he have the experimental equipment necessary for close monitoring of actual cannonball trajectories. Instead, the resourceful engineer resorted to observation and analysis of jets of water in Manuscript C, folio 7 recto

(right), and related their trajectories to those of projectiles. Unlike Galileo more than a century later, Leonardo recognized the role played by air resistance. To lessen that resistance, he proposed far ahead of his time the streamlining of missiles and providing them with directional fins (left) in Codex Arundel, folio 54 recto.

of the inadequacy of his experimental equipment, Leonardo perceived the parabolic nature (without naming it as such) of ballistic trajectories. He recognized the important role of air influencing the curve, whereas Galileo considered air resistance negligible.[15] The marvelous ogive-headed projectiles provided with directional fins that were drawn by Leonardo several times illustrate a practical application of this recognition (p. 108). Leonardo studied also the more manageable curves of jets of water issuing from an orifice under varying heads of pressure and related these to projectile curves (below). Torricelli, who followed the steps of Galileo, still neglected air resistance when tracing his ballistic curves.[16] But experimenting with water jets, Torricelli, like Leonardo 150 years before, observes that even if they describe a parabola, their descending

Test in order to make a rule of these motions. You must make it with a leather bag full of water with many small pipes of the same inside diameter, disposed on one line.

part is *magis prona,* that is, deformed by the resistance of the medium.[17] The mathematical solution of the ballistic curve involving air resistance was provided by Newton in 1687.

A contribution was made by Leonardo to the then still novel mechanism for firing handguns, the matchlock. In a set of drawings of about 1495 are shown three matchlock mechanisms for uncovering the pan that holds the priming

gunpowder at the barrel touchhole and applying simultaneously the lighted match in the form of a slow-burning wick soaked in nitre, not shown in the drawings (below). Leonardo wrote, "The purpose of this mechanism is to get fire to the touchhole at the pan g and simultaneously to open the powder charge to be ignited." Action on the trigger, right, causes the complex of levers, springs, and bearings to lift the protective plate over the pan and apply the match held in the jaws of the "serpent" shown on the right of the coacting mechanism.

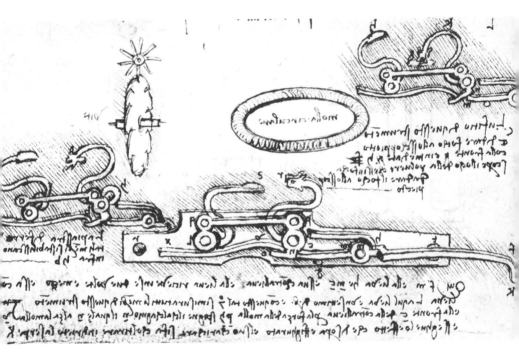

The effectiveness of the hand-held gun was recognized in the century 1470–1570. The arquebus with its clumsy matchlock evolved into the musket with its various types of firing mechanisms, including the flintlock. To Leonardo goes the credit for the earliest representation of a functioning wheel lock.[18] This can be seen from the several alternative forms in the sketches in the Codex Atlanticus [19] where a connecting chain from the mainspring to the wheel spindle is shown (page 111). Leonardo sketched, in section, the main heavy coil spring, the tripping mechanism, right, and the sparking pyrites holder, left. This design, however, drew the attention of historians of technology more for its clear

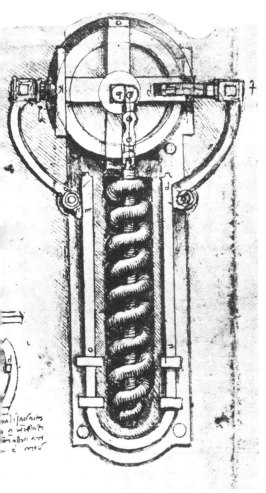

The matchlock – which fired a handgun by igniting powder with a slow match – was still a novelty about 1495, but Leonardo already was at work improving it. In the wonderfully sinuous drawing at far left, Madrid I, folio 18 verso, he sketches three mechanisms for simultaneously opening the powder charge and getting fire to the touchhole. The match is gripped by the jaws of the "serpent" (top right of the drawing) and struck when the trigger is pulled. Nonetheless, the matchlock was a clumsy way to fire a gun and about five years later Leonardo came up with a clearly better method. The drawings at the left, Codex Atlanticus, folio 56 verso-b, are the earliest known representation of the wheel lock, which historians ascribe to a Nuremberg watchmaker 15 years later. The top sketch shows the steel wheel and helical mainspring. Next to them is the holder for the pyrite material used as the flint. The bottom sketch shows the trigger mechanism, which forces the wheel to rub against the flint and produce a spark, as in the modern cigarette lighter.

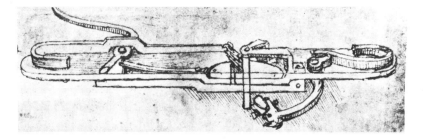

Leonardo's obsession with multiple effects in his weaponry led him to ingenious designs that were the forerunners of modern rapid-firing arms like the machine gun. His concepts called for a single artillery piece with a number of barrels, like the Gatling gun (right), which would not be invented until 1862 during the American Civil War.

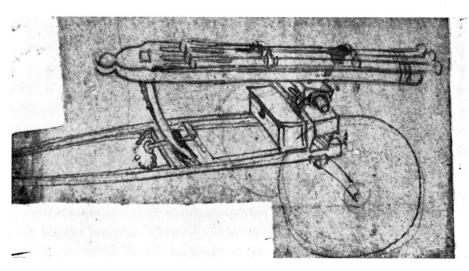

showing of a chain-and-sprocket linkage than as a gunpowder-ignition mechanism. Leonardo's sketch is believed to have been made by 1500, but the earliest wheel-lock mechanism is credited to a Nuremberg watchmaker 15 years later. The complex wheel lock continued in use for two centuries. Although it was more efficient than the flintlock, complexity and efficiency lost out to the simpler and cheaper flintlock until it also was replaced by the percussion musket with the fulminating cap in the mid-1830s and by the magazine rifle of 1890. The wheel-lock principle carries over into the modern flint-and-wheel cigarette lighter.

A favorite design theme for Leonardo was the multiple-barrel light cannon that approached the structure of the Gatling gun. By this means he tried to attain rapid fire, simpler manipulation, and more accurate aim (or widescattering of the shot) on the target (p. 112). The designs also permit the reloading of the powder and shot to proceed while the artillerist fires one set of guns and while the second set cools before being loaded (p. 114). These drawings of multiple-barreled guns illustrate both Leonardo's artistry and advanced designs. The traction wheels are represented by simple circles.

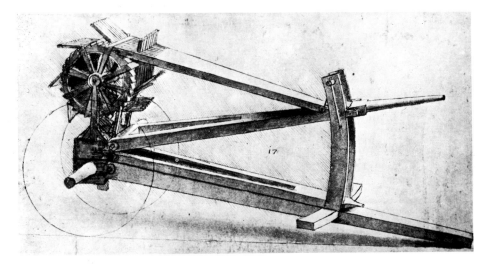

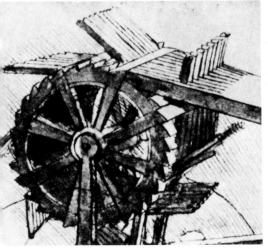

A relatively simple Leonardo design with several barrels is shown on the opposite page from Codex Atlanticus, folio 340 recto-b. A more complex version (above) from Atlanticus, folio 3 verso-a, has revolving racks of barrels, shown in enlarged detail at left, that enable the cannoneers to load one rack while a salvo is being fired from another set of barrels.

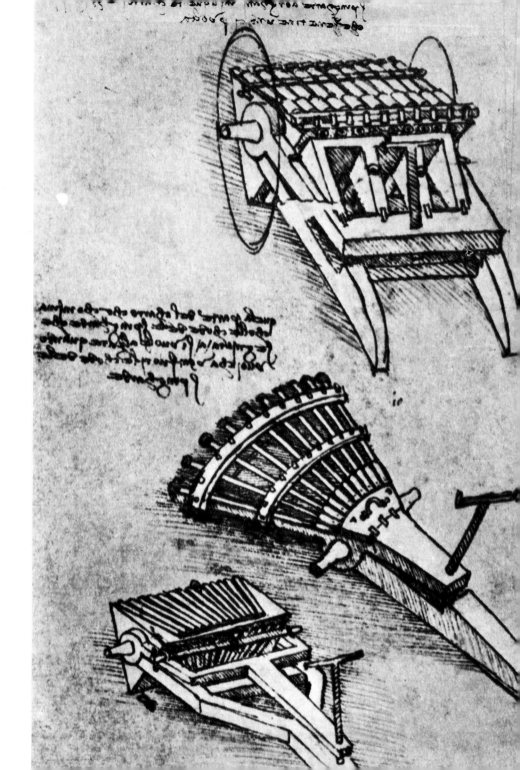

Organ-like artillery. Over this cart there
must be 33 guns, which will be fired 11 at a time.

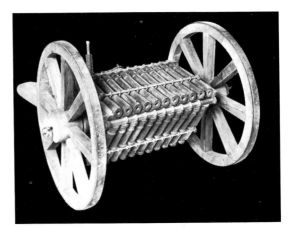

The section of the waggon which is close to
the ends of the springalds and
marked a, will raise itself when
you want to extract the rails of the springalds.

The famous drawing on the opposite page, Codex Atlanticus, folio 56 verso-a, brings together two designs. In the center Leonardo cants the barrels to allow widescattering of the shot and provides a jack handle for raising or lowering the trajectory. At top and bottom the designs have rotating racks of barrels. The photograph above shows an actual model reconstructed from the drawing of the battery at top, consisting of three racks of 11 cannons each mounted on a triangular frame. Researchers have reconstructed models of a number of Leonardo's designs for weapons and machines. In building some machines they have found obvious mistakes in the drawings – a redundant wheel or extra gear – possibly put there deliberately by Leonardo to prevent others from stealing his designs and calling them their own.

An unusual piece of artillery was designed and termed *architronito* by Leonardo. This consisted of a cannon that depended on the sudden generation of steam to drive the shot out of the barrel. The breech was built into a basket-like brazier containing the burning coals. With the shot rammed back and the breech section sufficiently heated, a small amount of water was injected into what would normally be the powder chamber. "And when consequently the water has fallen out it will descend onto the heated part of the machine, and there it will instantly become changed into so much steam that it will seem marvelous, and especially when one sees its fury and hears its roar. This machine has driven a ball weighing 1 talent 6 stadia" (below). This would indicate that such a gun had actually been made. Evidently the rate of fire was a lesser consideration. Putting steam's expansive power to work was novel

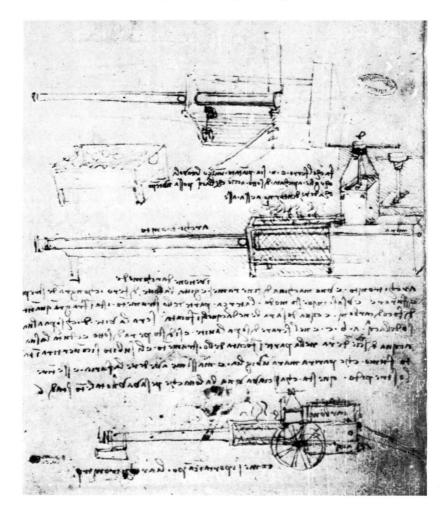

indeed, in Leonardo's time. The idea was by no means impractical. Steam cannons were used during the American Civil War and even in the Second World War (Holman projectors).[20]

A journey into future mechanization and use of hydraulic power (to wit, Pelton-type turbine blades) is made by Leonardo in a remarkable design for an assembly of elements to draw sections to form the barrel of a cannon. Large cannon were built up by combining forged tapered segmental sections to form the barrel, then binding the segments together by driving metal rings upon the barrel segments, much like driving hoops upon barrel staves, or by winding multiple layers of steel wires. Leonardo's scheme for drawing gun-barrel segments is one of several such proposed methods (p. 119). Starting with the prime mover, a horizontal water-driven reaction turbine shown at the lower left of the assembly as illustrated by Leonardo, the vertical power shaft drives the two geared wheels through a common worm. This causes the shaft attached to the left wheel to turn and give power to its own worm. The gear set horizontally is caused to turn, thereby powering another vertical shaft and yet another worm. The engaged large vertical gear in the back is thereby rotated, and its power, now greatly multiplied (at a slower turning speed), is passed through the square shaft to the wheel on the right. This wheel is sturdily built and heavily armored by a helicoidal cam shown in the upper left sketch. Its purpose can be seen by following the sequence of operations passing from the prime mover through the gear wheel engaged on the right of its worm. This gear wheel has fastened to it an internally threaded shaft, through which rides a long threaded rod.

As the right gear wheel is turned, the threaded rod is drawn forward, thereby pulling a blank rod after it. This blank rod is forced into a segmental shape shown above the column of writing at the right. In addition, by means of the heavy cam pressure the breech end is drawn heavy, the muzzle end light, their inner-arc radii remaining the same. In the diagram below the drawing

Leonardo's ideas for putting the power of steam to work predated the designs of scientists who lived centuries later. The design (left) for the cannon he calls architronito — *a word he coined — depends upon steam instead of gunpowder to fire the projectile. A brazier of burning coals heats the breech of the cannon. When water is poured into the powder chamber, writes Leonardo, "it will instantly become changed into so much steam that it will seem marvelous, and especially when one sees its fury and hears its roar."*

appears the schematic power ratio due to the gearing. Starting with the figure 1,000 at the turbine, there appears 12,000 at the first gear, 144,000 at the horizontal gear, 1,728,000 at the top big gear, and 20,736,000 at its shaft. A mechanical-advantage ratio of 1:12 is created at each step. Leonardo certainly knew the reduction of forces by friction, even though he does not seem to apply it here. Roller and ball bearings for friction reduction are one of his frequently used design elements.[21]

Some elaborate applications of ball and roller bearings are shown in several devices in the rediscovered Madrid material, where also the general subject of friction and friction-bearing materials is discussed. One also observes in these new notes Leonardo's striving for optimum mechanical advantage with a minimum of friction. The Madrid Codices feature quite a number of mechanisms depending on ball and roller bearings and, to the surprise of many modern designers, on conical bearings. Leonardo experimentally determined an average coefficient of friction of one-quarter the weight of a flat-surfaced object.[22] He scoffed at perpetual motion and moved towards the elements of automation that one expects of modern mechanisms. In military affairs he aimed at replacing the vulnerable horse in battle by protected muscle-propelled vehicles. He was conscious of the lack of a motive prime mover (which came in our time with steam, the gas engine, and the electric motor).

The Madrid Codices are replete with designs and problems in technology, optics, structures, topography, statics, and dynamics. These weigh heavily when one is considering the question, was Leonardo essentially an artist, scientist, or engineer? The conversion of those many pages of fine notes and diagrams into man-days would indicate a deep involvement on Leonardo's part with the structure and behavior of the physical world. The satisfactions that feed the spirit in the artist seem equally nurtured by the problems in matter and force that Leonardo posed and by the delight he took in solving them.

At right, Leonardo designs a new machine tool for war. A hydraulically driven turbine powers the mill, which forms cannon barrels too large for traditional forging methods. In a remarkable complex sequence of co-ordinated actions, the mill fashions smooth, even segments for the barrel. The segments are then welded and banded together.

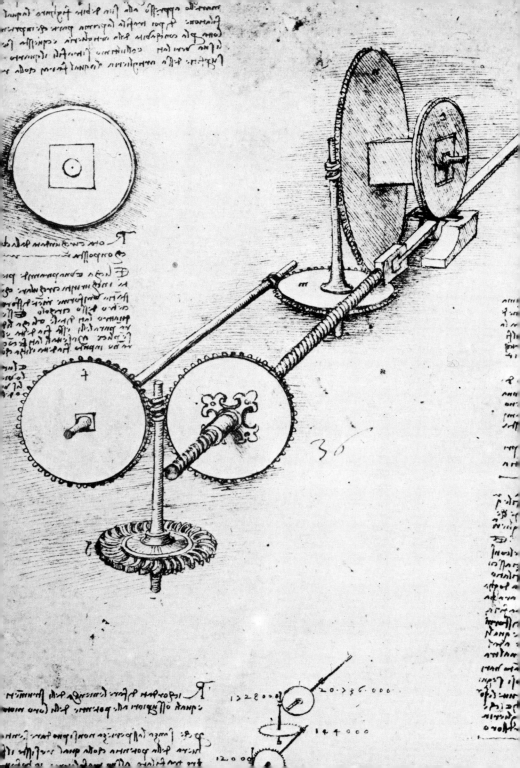

The *fanciful artist and the practical military engineer join forces for a naval battle. At the top are two guns with barrels mounted on long shafts. The first one is to be fired by a tinder on a lever worked by a long string. The tube below this contains powder for the second gun. Below these sketches is a set of tinders for a six-barrel gun. But clearly it is the one-man battleship that captures Leonardo's fancy. A boxlike mortar is mounted on a revolving cradle manned by the lone sailor. From its side the mortar pours out awful salvos of a kind of Greek fire – incendiary shells – that ravages the enemy ships with flame. Ordinary cannonballs seemed old-fashioned to Leonardo. His idea for an incendiary bomb was one studded with spikes, and he proposed catapulting poison shells at the enemy so that "all those, who, as they breathe, inhale the said powder with their breath will become asphyxiated."*

This huge mortar looks much like the powerful new cannon used in the American Civil War (below). The shrapnel are filled with powder and pocked with holes so that upon impact they will explode and scatter deadly fragments. Leonardo describes the shrapnel shell, in his Manuscript B, as "the most deadly machine that

exists . . . the ball in the center bursts and scatters the others which fire in such time as is needed to say an Ave Maria." Leonardo hated war, calling it "beastly madness." Even in this, he seems to anticipate many scientists of the 20th century – abhorring war and yet putting his great genius into its employ.

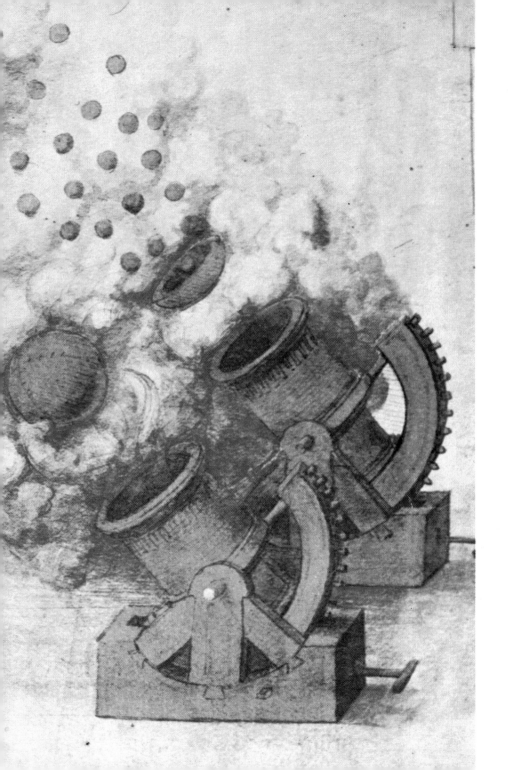

"…nor did his mind
ever come to rest, but dwelt
always with ingenuity on the creation
of new inventions."

ANONIMO GADDIANO

THE ENGINEER

LADISLAO RETI

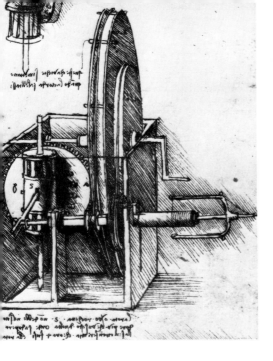

Precision of hand and mind enable Leonardo to communicate his ideas for mechanical contrivances in sketches more explicit than words. The drawings here, in Codex Atlanticus, folio 393 verso-a, depict the workings of an automated spool-winding machine. The crank turns the bobbin and flyer in opposite directions as the gear mechanism moves the flyer back and forth to distribute the thread evenly on the bobbin.

Leonardo's interests were extraordinarily diversified: his notes and sketches bear witness to an intellectual hunger that includes all human knowledge, from geometry to mechanics, from anatomy to botany, from geology to astronomy. And even accepting that the largest and perhaps best part of Leonardo's legacy is lost – a conservative estimate points to the disappearance of about 75 percent of his work – it is reasonable to assume that the qualitative and quantitative distribution of the subjects treated by Leonardo is well represented in the material that has come down to us.

While no more than 10 paintings indisputably by the master's hand can be admired on the walls of the world's greatest art galleries (a disturbing aspect of the inventory of what remains of his works) and the drawings of a purely artistic nature are estimated to number a few hundred, thousands of studies and drawings dealing with geometry, mechanics, and engineering point to the predominant interests of Leonardo. The two manuscripts recently brought to light in Madrid add to the already impressive gathering almost 700 pages of technical drawings and notes only accidentally interrupted by unrelated subjects.

Every official appointment Leonardo received refers to him not only as an artist but as an engineer as well – at the court of Lodovico il Moro, for example, where

Bridge from Pera to Constantinople 40 braccia wide, 70 braccia high above the water, and 600 braccia long; that is, 400 over the sea and 200 resting on the land, providing by itself its abutments.

One of Leonardo's engineering visions was of a colossal bridge over the Golden Horn at Istanbul, which he offered to undertake for the Sultan of the Ottoman Empire. Above, in Manuscript L, folio 66 recto, he sketches the bridge from overhead and in elevation and notes the dimensions of the 1,150-foot-long structure. The photographs at right show comparable views of a model of the bridge at the National Museum of Science and Technology in Milan.

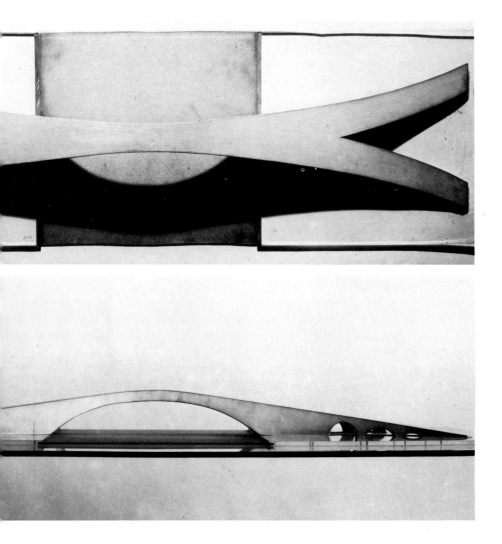

he remained nearly 20 years, he was "engineer and painter"[1] – and correspond-ingly, his scientific and technological activities were well known to, even if not always approved by, his contemporaries and early biographers. They became more noticeable when he started to neglect his artistic activities as he became more and more involved in science and technology. In April 1501 Fra Pietro di Novellara, agent of Isabella d'Este, the Marchesa of Mantua, in the course of efforts to persuade Leonardo to accept an artistic commission from his mistress, wrote her describing some ongoing painting activity of the master and assuring

her of the good will of Leonardo, but also pointed out that "he is so much distracted from painting by his mathematical experiments as to become intolerant of the brush."[2] Isabella pursued Leonardo for years with letters and intermediaries in order to obtain from him a painting; her admirable patience was in vain.

In technology Leonardo set his sight beyond the bounds of Italy and even Europe. Thus on a page of Manuscript L that is datable 1502–1503 there is a small sketch representing a bridge in plan and elevation, with its accompanying text: "Bridge from Pera to Constantinople 40 braccia wide, 70 braccia high above the water, and 600 braccia long; that is, 400 over the sea and 200 resting on the land, providing by itself its abutments."[3]

This grandiose project might appear to be just a flight of fancy were it not for some significant circumstances first pointed out by J. P. Richter.[4] Richter believed that the sketch must have been made about 1502, when ambassadors of Sultan Bajazet II of the Ottoman Empire were in Rome looking for Italian engineers to replace the bridge of pontoons over the Golden Horn by a permanent structure. Vasari's life of Michelangelo, cited by Richter, relates the sultan's plans to Michelangelo, saying that "he thought of going to Constantinople to serve the Turk by means of some Franciscan friars, from whom he learned that the Turk wanted him to make a bridge between Constantinople and Pera."[5] But in 1952 a surprising piece of evidence involving Leonardo came to light. Franz Babinger, examining a document found in the archives of the Topkapi Serayi in Istanbul, recognized it as a Turkish translation of a letter by Leonardo da Vinci offering Sultan Bajazet II his services for the execution of four engineering projects.[6]

The projects were a special kind of windmill, an automatic device for pumping a ship's hull dry, the construction of a bridge between Galata and Istanbul, or Constantinople, and the erection of a drawbridge in order to reach the Anatolian coast. Babinger, assisted by Ludwig H. Heydenreich, dates this document around 1502–1503, which corresponds to the period of Manuscript L. And in Manuscript L we find not only the sketch and the description of the bridge between Pera or Galata and Constantinople but also constructive details for windmills[7] and a sketch for a pump for draining ship hulls.[8]

In Giorgio Vasari's biography of Leonardo[9] we find a reflection of the sentiments of contemporaries faced by such behavior in a man endowed by Providence with such great artistic gifts, as well as testimony about the variety of Leonardo's technological projects that is important in assessing the influence of Leonardo on

128

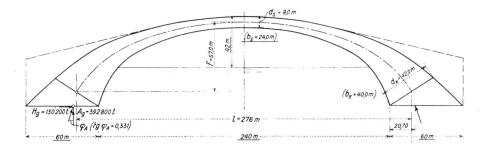

Leonardo's bridge would have arched so high above the water, he wrote Sultan Bajazet II, that a ship with sails up could pass under it. The diagram above shows the dimensioning of a modern Swiss scientist, D. F. Stüssi of Zurich, who concluded that the plans were technically feasible. Below, the model in the Milan museum.

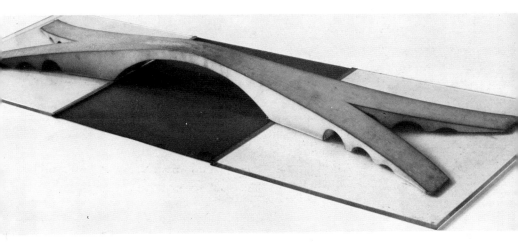

the development of technology: "He would have made great profit in learning had he not been so capricious and fickle, for he began to learn many things and then gave them up . . . he not only worked in sculpture . . . but also prepared many architectural plans and elevations, and he was the first, though so young, to propose to canalise the Arno from Pisa to Florence. He made designs for mills, fulling machines and other engines to go by water. . . . By the grace of God he was endowed with a terrible gift of reasoning that, combined with intelligence and memory and a capacity of expressing himself by means of his drawings, enabled him to confound the boldest opponents. Every day he made models and designs for the removal of mountains with ease and to pierce them to pass from one place

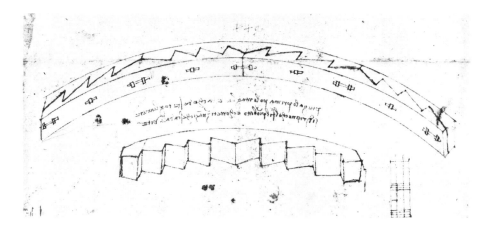

A Leonardo method of bending beams into arches found expression more than 300 years later in Swiss wooden bridges. His drawing above, in Codex Atlanticus, folio 344 verso-a, demonstrates how the beams can be notched so that the fibers in the wood will not split. The wooden bridge at bottom, built in 1839 in Signau in the canton of Bern, has two bearing arches constructed precisely as in the Leonardo drawing. A detail of the bridge shows the interlocking of the bent and notched timbers in one of the bearing arches. About 155 feet long, the bridge spans the Emme River and has a load

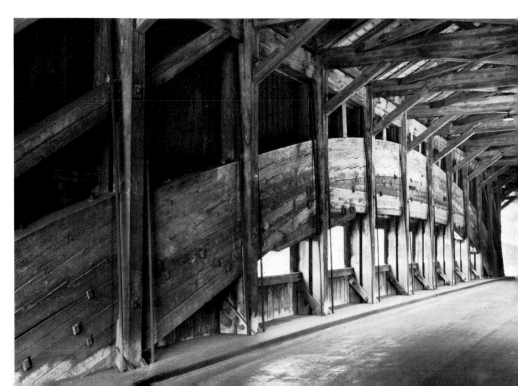

capacity of more than 40 tons. Another
bridge of similar construction in the same
canton spans nearly 200 feet. Bridges of
this type, unknown before the 19th century,
represent another modern application of
Leonardo's thinking.

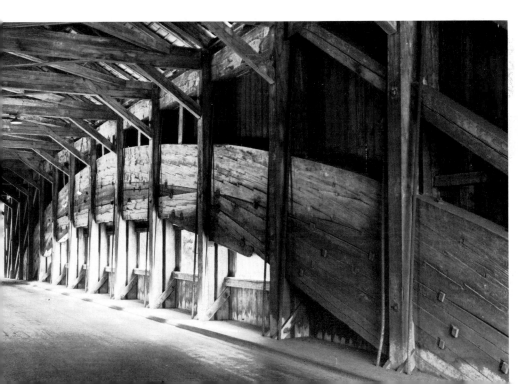

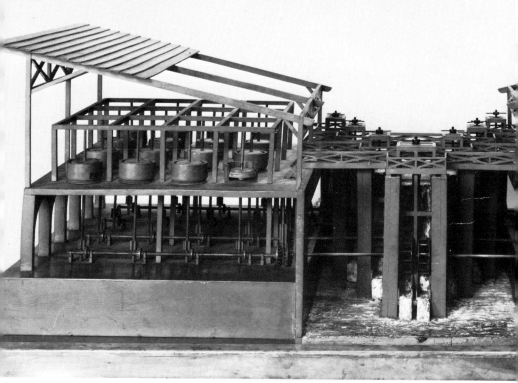

to another, and by means of levers, capstans and screws to raise and draw heavy weights; he devised methods for cleansing ports and to raise water from great depths, schemes which his brain never ceased to evolve. Of such ideas and efforts many designs are scattered about, and I have seen many of them. . . ."

And after Leonardo's death, more seems to have remained than models and designs. For example, the distinguished Milanese cleric Giovanni Ambrogio Mazenta (1565–1635), who once had 13 of Leonardo's manuscripts, left in his memoirs testimony of Leonardo's technical activities in Lombardy.[10] The information contained is significant because it is based on widespread tradition still alive at the time and on the content of books by Leonardo that Mazenta had in his hands. He speaks of "Leonardo's invention of machines and gates to level, intercommunicate and make navigable" the waterways connecting the Lombard lakes.

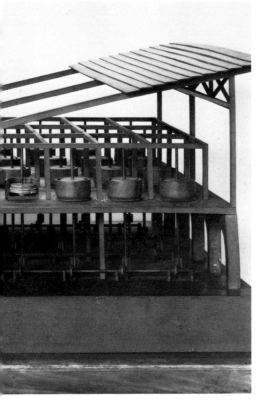

His surviving drawings and writings and the accounts of his contemporaries attest to Leonardo's interest in the design of water-powered gristmills. The sketch above, in Codex Atlanticus, folio 304 verso-b, is for a large-scale mill. Below, again at the National Museum of Science and Technology in Milan, is a model of the mill.

He also speaks of the "many machines depicted in the . . . books, that have been put to use in the region of Milan, like weirs, locks and gates, mostly invented by Leonardo." And he speaks of other technical contributions by Leonardo: "In the *botteghe* of the arts, many machines invented by Leonardo are in use, for cutting

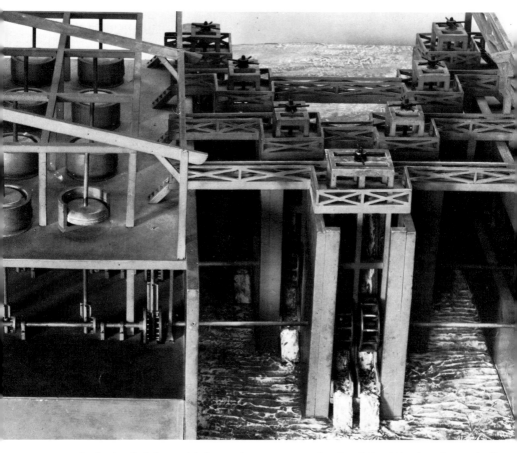

In the detail of the model shown above can be seen the two front waterwheels and the connecting shafts that power the mills on the upper level. The 16th-century Italian painter and writer Giovanni Paolo Lomazzo recalled a collection of 30 sheets by Leonardo depicting mills "some of them moved by water and some not, all different from each other." In Atlanticus Leonardo lists 11 kinds of uses for such water mills, including silk spinning and the manufacture of gunpowder.

and polishing crystal, iron and stones; and there is one much used in the cellars of Milan, for grinding large amounts of meat to make *cervellato* – [a Milanese specialty, a sausage made with pork meat, and brain] with the help of a wheel turned by a boy without being troubled by flies or stench." "There are also many sawmills for marble and wood on the rivers and sand dredges on boats moved by the stream."

All this and much more historical evidence, pointing to Leonardo's double vocation and the actual fulfilment of important technical works, contradicts by itself the opinion of a number of contemporary scholars, who have questioned the possible influence of Leonardo upon the development of the mechanical arts and even the practicability of his technological projects. Yet even as recently as the

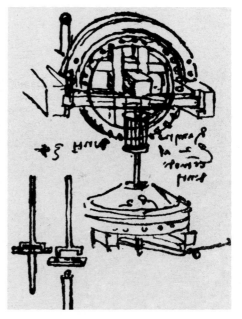

Mills powered by the wind were of little significance in Italy because of unfavorable meteorological conditions. The two sketches for a windmill above were probably made in connection with Leonardo's offer of his services to Sultan Bajazet II of the Ottoman Empire. Leonardo's letter to the sultan, written about 1502, came to

light in a Turkish translation that was found in 1952. Leonardo said that, in addition to a windmill and the bridge over the Golden Horn (page 126), he could build a drawbridge and an automatic device for pumping out the hull of a ship.

MS. L 35v, 34v

135

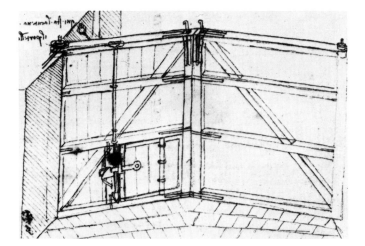

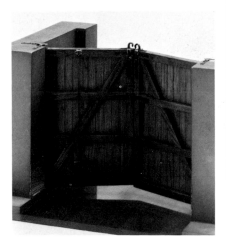

Leonardo's longtime fascination with the creation of a waterway from Florence to the sea resulted in a number of hydraulic contrivances. He devised the ingenious sluice gates above, in Codex Atlanticus, folio 240 recto-c, to control water levels. The key to their operation is in the lower part of the left-hand gate – a simple trapdoor controlled by a latch from above. Opening the trapdoor permits water to flow in and equalize the pressure on both sides so that the main gates

can be opened. The photograph at left shows a model of the sluice gates, complete with trapdoor, built by A. De Rizzardi for the National Museum of Science and Technology in Milan. Another model by De Rizzardi (right photo) is based on Atlanticus, folio 46 verso-a. It demonstrates one of Leonardo's ideas for the use of the sluice gates – to control the level of a canal that carries a boat across a bridge.

1950s and 1960s some have done so. To cite only two of many possible examples:

In a book by Leonardo Olschki, published in 1950, Leonardo da Vinci's technological work is assessed as follows: "Leonardo's technology still belongs to the traditional type of antiquity and the Middle Ages; it was highly developed craftsmanship, with no attempt to apply scientific principles. . . . His scientific and technological work is little more than a mass of eloquent literary fragments and realistic drawings, of ingenious projects that would hardly have withstood a practical test."[11] There is no need to answer this except to say that were Olschki right, numerous distinguished scholars who have found to the contrary would have toiled in vain.

The second example is more specific. At a 1952 international congress in observance of the 500th anniversary of Leonardo's birth, Bertrand Gille, speaking of Leonardo's attempts to convert rotary to reciprocating motion, said that "when Leonardo tries to find the solution of the problem of the transformation of a continuous circular motion into an alternating reciprocal motion, he imagines the most unlikely solutions before ending simply with the rod-crank system known since the start of the 15th century."[12] Further, in the 1960s, Joseph Needham, in his monumental *Science and Civilisation in China,* accepted Gille's statement.[13] In fact a review of the Vincian corpus provides a count of 137 single-crank motions and 67 crank-and-rod motions, most of them connected with a piston rod, some transmitting the movement to a second crank or to swinging devices. Additionally, Codex Madrid I includes 104 simple and 24 compound crank motions.

On an admirable page of this codex[14] Leonardo not only discusses the theory underlying its use but also refers to it as a device generally known to practitioners. There is a legend that James Watt was obliged to resort to complicated transmission systems because the crank-and-rod transmission had been previously patented. The truth is that engineers were afraid of applying the simple crank-and-rod motion to the steam engine because it was imagined that the engine would stop or turn back or that something would give way as a consequence of the irregularity of the stroke of a steam piston. No one, not even Watt, could believe that the movements of a reciprocating engine could be controlled by means of a flywheel and a crank.[15] Had Watt seen Leonardo's illuminating page, where the theory of the crank-and-rod motion is discussed in connection with that of the flywheel, he would perhaps have been less reluctant to adopt it in his steam engine.

Every day he made models and designs for
the removal of mountains with ease and to pierce
them to pass from one place to another,
and by means of levers, capstans,
and screws to raise and draw heavy weights;
he devised methods for cleansing ports
and to raise water from great depths,
schemes which his brain
never ceased to evolve.
Of such ideas and efforts
many designs are scattered about,
and I have seen many of them.

An important witness to Leonardo's influence on the technology of his time was Giorgio Vasari. In the excerpt above from the Lives of Painters he writes of Leonardo's technological accomplishments and notes that even then – Vasari was first published in 1550 – much of Leonardo's work already was "scattered about."

But I shall not discuss at any further length Leonardo's scientific and technological work in order to affirm the validity of my positive point of view. Instead, I shall attempt to let Leonardo speak for himself and shall limit my comments to explaining the meaning of what he says when the distance in time of his language makes the interpretation difficult and to putting Leonardo's ideas in the place where they belong in the history of the technical arts. In the introduction to his book *The Kinematic of Machinery* (1876), which is a classic in its field, Franz Reuleaux, the founder of the modern theory of mechanisms, discusses the principles by which a machine should be studied and defined. One of its passages runs as follows: "In earlier times men considered every machine as a separate whole, consisting of parts peculiar to it; they missed entirely or say but seldom the separate groups of parts which we call mechanisms. A mill was a mill, a stamp a stamp and nothing else, and thus we find the older books describing each machine separately from beginning to end. So for example Ramelli (1588), in speaking of various pumps driven by water-wheels, describes each afresh, from the wheel, or even from the water driving it, to the delivery pipe of the pump. The concept 'waterwheel' certainly seems tolerably familiar to him, such wheels were continually to be met

An eminent contemporary who came under the influence of Leonardo's artistic and technological projects was the German artist Albrecht Dürer (left). The son of a goldsmith, Dürer was born in Nuremberg but traveled widely. He went to Italy at least twice, in 1494 and in 1505, for a long sojourn in Venice. His engravings, woodcuts, and paintings show the effects of his contact with the work of Leonardo and the other Italian masters. Though there is no evidence that Dürer met Leonardo, he must have seen some of his works, including manuscripts now considered lost. He borrowed the knotwork pattern that Leonardo wove through the decoration of the Sala delle Asse, adopted some of his ideas for drawing instruments and was influenced by Leonardo's representation of horses.

The most dramatic example of Leonardo's effect on Dürer is evident in the German's master engraving Knight, Death, and the Devil (below). The knight is transplanted almost unchanged from Dürer's drawing of 15 years earlier Man in Armor on Horseback. But the horse, wooden and lifeless in the earlier work, has come alive – and looks remarkably like Leonardo's studies for his equestrian Sforza monument (below, Windsor 12347 recto). Scholars suspect that Dürer saw Leonardo's lost work on horse anatomy and his studies of human anatomy, which apparently also had a profound effect on the German.

with, only the idea 'pump' – and therefore also the word for it – seems to be absolutely wanting. Thought upon any subject has made considerable progress when general identity is seen through the special variety; – this is the first point of divergence between popular and scientific modes of thinking. Leupold (1724) seems to be the first writer who separates single mechanisms from machines, but he examines these for their own sakes, and only accidentally in reference to their manifold applications. The idea was certainly not yet very much developed. This is explained by the fact that so far machinery has not been formed into a separate subject of study, but was included, generally, under physics in its wider sense. So soon, however, as the first Polytechnic School was founded in Paris in 1794, we

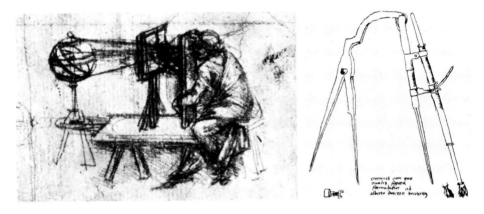

Two of Leonardo's devices for aiding the artist that were adopted by Albrecht Dürer are shown above. The perspectograph, in Codex Atlanticus, folio 1bis recto-a, was a device that permitted the artist to see and draw from a fixed position in true perspective – a subject of great interest to the mathematically inclined Leonardo. The ellipsograph, shown above right in a copy after Dürer (Albertina, Vienna) based on Leonardo's lost drawing, was known to medieval Arab mathematicians and may have existed in ancient times. In Leonardo's version, three legs of the compass formed a triangle and the tube holding the brush proved able – in a modern working model made from the sketch – to inscribe perfect ellipses.

Opposite:
Leonardo's interest in mathematics led to the use and even invention of a wide variety of compasses. He drew devices for making parabolas and ellipses and a proportional compass that would form a figure similar to another and in given proportion to it. The pair of compasses shown here are from Manuscript H, folio 108 verso. The same compasses also appear in a book by Benvenuto Lorenzo della Golpaja, a collection of drawings based on inventions by his father and several contemporaries including Leonardo. The volume contains many references to Leonardo's technological accomplishments.

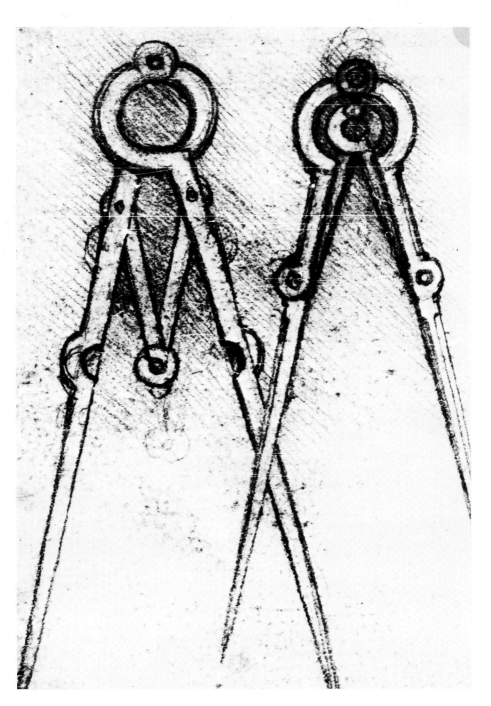

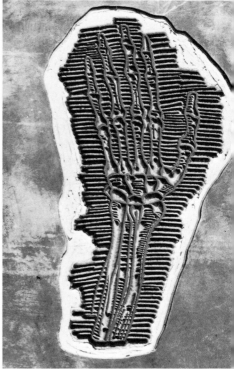

Despite the invention of printing with movable type about the time of Leonardo's birth, none of his works was published until 132 years after his death. This irony is compounded by a revelation in the rediscovered Madrid Codices: Leonardo had prescribed a method of printing that could have made his drawings and text widely available. Leonardo was aware that the woodcuts then in use could not adequately reproduce his finely detailed drawings and that the new metal engravings were too costly. His method produced a new kind of relief etching on metal. In Codex Madrid II, folio 119 recto, he set down precise details "Of casting this work in print. Coat the iron plate with white lead and eggs and then write on it lefthanded, scratching the ground. This done, you shall cover everything with a coat of varnish, that is, a varnish containing gial-lolino or minium. Once dry, leave the plate to soak, and the ground of the letters, written on the white lead and eggs, will be removed together with the minimum. As the minimum is frangible, it will break away leaving the letters adhering to the copper plate. After this, hollow out the ground in your own way and the letters will stay in relief on a low ground." Following these instructions, a modern Italian artist, Attilio Rossi, succeeded in reproducing a fine line block (above left) after one of Leonardo's drawings of a hand, Windsor Collection No. 19009 verso. Three centuries after Leonardo, the mystic poet and artist William Blake reinvented the same etching process. The Blake method was improved in 1850 by the Frenchman Firmin Gillot, and became the basis for modern relief printing.

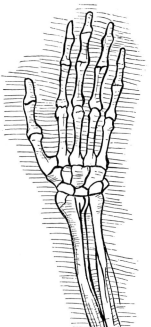

Leonardo's anatomical drawing was made into a relief etching by his own method (far left) and by modern means (center). At left is the hand as reproduced by Leonardo's etching method.

see the separation between the study of mechanisms and the study of machinery, for which the way had thus been prepared, systematically carried out."[16]

It has been pointed out that the notebooks of Leonardo afford ample evidence of the existence of this separation in his mind.[17] But whereas up to the rediscovery of the Leonardo manuscripts in Madrid this evidence was scattered and fragmentary, Codex Madrid I, datable around 1495, proves beyond doubt not only that Leonardo had adopted this outlook, characteristic of modern minds, but also that in this work he attempted to compose a true treatise on the composition and work of machines and mechanisms in general.

This recognition comes as a surprise to the historians of technology, who have traditionally seen in the work of early 19th century scholars of the Ecole Polytechnique the first systematic approach to the study of what were called elements of

machines or mechanisms. According to Reuleaux, the constructive elements of machines can be listed as follows:

1. Screws
2. Keys
3. Rivets
4. Bearings and plummer blocks
5. Pins, axles, shafts
6. Couplings
7. Ropes, belts and chains
8. Friction wheels
9. Toothed wheels
10. Flywheels
11. Levers and connecting rods
12. Click wheels and gears
13. Ratchets
14. Brakes
15. Engaging and disengaging gears
16. Pipes
17. Pump cylinders and pistons
18. Valves
19. Springs[18]

The following important elements, which Reuleaux handles in another section, must be added:

20. Cranks and rods
21. Cams
22. Pulleys[19]

Of the elements listed by Reuleaux, only the rivets are apparently missing in Leonardo's manuscripts. This is not because rivets were unknown in Leonardo's time, but because he deliberately desired to present "instruments ... without their armatures or other structures that might hinder the view of those who will study them."

That Leonardo wanted to compose a book of mechanisms and not just of machines is manifested by the extremely interesting page containing the phrase above – a page that was evidently intended to serve as an introduction:

"We shall discuss here the nature of the screw and of its lever, and how it [the screw] shall be used for lifting rather than for thrusting; and how it has more power when it is simple and not double, and thin rather than thick, when moved by a lever of the same length and force. We shall briefly discuss the many ways there are to use screws, the various types of endless screws, and the many motions that are performed without screws, but which serve the same purpose; how the endless screw shall be combined with toothed

The intention to compose a book on the elements of machines is set forth in Codex Madrid I, folio 82 recto. This text, with accompanying transcription (opposite page), makes clear a trait that set Leonardo apart from technologists of his time and long after: an understanding of individual mechanical elements as distinct from whole machines.

Overleaf: This chart compares mechanisms known by Leonardo with the 22 elements of machines listed by the 19th-century German Franz Reuleaux in The Kinematic of Machinery. *In Codex Madrid I, nearly 400 years before, Leonardo described and drew all but two of the elements – pump cylinders and pistons, which are found in Codex Atlanticus, and rivets, which he had purposely excluded.*

145

THE ELEMENTS OF MACHINES

REULEAUX LEONARDO

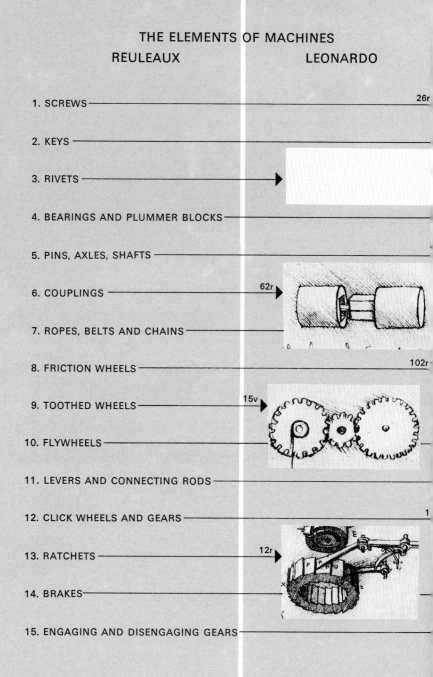

1. SCREWS ————————————————————— 26r

2. KEYS ————————————————————

3. RIVETS ————————————————

4. BEARINGS AND PLUMMER BLOCKS ——————

5. PINS, AXLES, SHAFTS ——————————————

6. COUPLINGS ———————————— 62r

7. ROPES, BELTS AND CHAINS ————————

8. FRICTION WHEELS ——————————— 102r

9. TOOTHED WHEELS ———————— 15v

10. FLYWHEELS ————————————

11. LEVERS AND CONNECTING RODS ————————

12. CLICK WHEELS AND GEARS ——————— 1

13. RATCHETS ———————————— 12r

14. BRAKES ————————————————

15. ENGAGING AND DISENGAGING GEARS ————

146

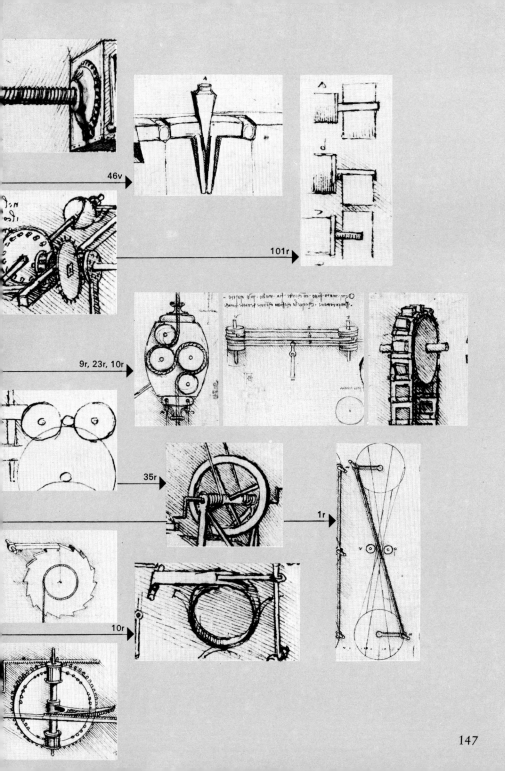

46v

101r

9r, 23r, 10r

35r

1r

10r

16. PIPES

17. PUMP CYLINDERS AND PISTONS ── Atl. 5r-b

18. VALVES

19. SPRINGS

20. CRANKS AND RODS

21. CAMS ── 6v

22. PULLEYS

wheels, and how to use many screws together. We shall examine the nature of their nuts, and if they are more useful having many threads or less. We shall also speak of inverted screws and screws that by a single motion thrust and pull a weight, and screws which, by turning them only once, will rotate the nuts more than once. And likewise, we shall discuss a great many of their effects and the variety of their labors and strengths, and slowness, and swiftness. Account, too, will be given of their nature and their uses, their composition, levers, and utility. Their method of construction will also be discussed, how to put them to work, and how some people were deceived because they ignored the true nature of the screw.

"All such instruments will generally be presented without their armatures or other structures that might hinder the view of those who will study them. These same armatures shall then be described with the aid of lines, after which we shall discuss the levers by themselves, the strength of supports,

and their durability and upkeep. We shall also deal with the differences existing between a lever operating with constant force, that is, the wheel, and the lever of unequal power, that is, the straight beam, and why the former is better than the latter and the latter more compact and convenient than the former. We shall also discuss the ratchet wheel and its pawl, the flywheel and the impetus of the motion, the axles and their wear; ropes and pulleys, capstans and rollers, will also be described. We shall describe how air can be forced under water to lift very heavy weights, that is, how to fill skins with air once they are secured to weights at the bottom of the water. And there will be descriptions of how to lift weights by tying them to submerged ships full of sand and then how to remove the sand from the ships."[20]

The notes of the last sentences must refer to a subject dealt with on one of the missing pages, because there is no trace of it in the book. It is very important and

shows once again the plunder to which Leonardo's ideas fell victim. The text hints at a method of salvaging sunken ships or cargoes by pumping air into skins secured to the object to be raised. This invention is credited to Bakker of Amsterdam, about 1688, and the vessels were called camels or caissons. They were used to lift the largest men-of-war over the shoals of the Zuider Zee. An improved version of the same system is still in use today.

Leonardo's summing up presented above is incomplete, but becomes quite comprehensive when integrated with a similar list found in a note in the Codex Atlanticus.[21] This note is important because the available evidence shows it to be contemporary with Codex Madrid I. More machine elements – 18 – are listed in the Atlanticus note, which it would appear was meant to complement the summary given in the Madrid manuscript.

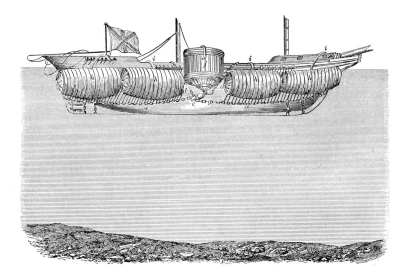

A new method for salvaging sunken ships is hinted at in the last item on Leonardo's list of intentions for a book of mechanisms quoted on the preceding page. The Dutch developed an idea apparently very similar to Leonardo's. By pumping air into containers called camels or caissons, which were attached to ships, they raised large men-of-war over the shoals of the Zuider Zee. An inventor known as Bakker of Amsterdam got credit for the device about 1688. In the 19th century a British sea captain named Austin evolved a similar method (above) for raising sunken ships by means of inflated bags. An improved version of the system is still in use today, as are several other of Leonardo's ideas for seagoing devices – including the life preserver and oversized buoyant shoes that enable men to walk on water.

It is noteworthy that Arturo Uccelli, in his book reconstructing the mechanical work of Leonardo,[22] included as an important part a section called Elementi macchinali ("Elements of machines"), observing at the beginning that very likely a work bearing this title had actually been written by Leonardo. A work on the "elements of machines" is often mentioned by Leonardo in his writings. We know now that it is not Codex Madrid I, but another work, divided into four books, or volumes, in which the theory of mechanical motions was discussed. On one page of Codex Madrid I Leonardo states, "Once the instrument is created, its operational requirements shape the form of its members. They may be of infinite variety but will still be subject to the rules of the four volumes."[23] In the Codex Atlanticus, on a page that is datable 1502 because it deals with the excavation of canals for Cesare Borgia, he mentions "the fifteenth conclusion of the fourth book composed by me on the elements of machines."[24] Apparently the same books are referred to on a great number of pages of Codex Madrid I itself, as proof of mechanical demonstrations, with numbers indicating similar subdivisions – e.g., ". . . and its toothing will be very durable, according to the seventh of the fourth, dealing with power and resistance."[25]

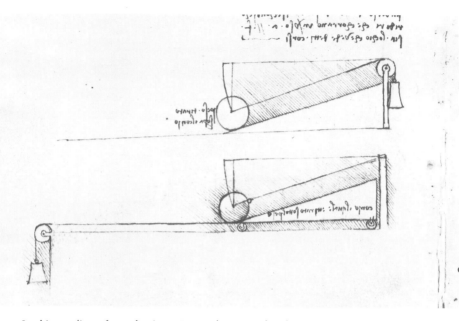

In his studies of mechanisms Leonardo clearly perceived how different elements were interrelated and mechanically equivalent. Above, in Codex Madrid I, folio 64 verso, he shows that pulling a weight up an inclined plane and pushing an equivalent wedge beneath the same weight require equal amounts of force. Folio 86 verso (above, right) compares the work of an inclined plane and a screw (a rolled-up inclined plane).

As Codex Madrid I is not so divided, it cannot be identified with the work *Elementi macchinali,* which unfortunately must be considered lost. What exactly Leonardo meant by this designation is difficult to ascertain; what is sure is that the term does not correspond to its modern meaning. The true book of the elements of machines is the first part of Codex Madrid I, devoted to practical mechanics. Possibly its second part, on theory, without being the original, may resemble in some respects the four lost books of Leonardo.

Be this as it may, it would be materially impossible even to recapitulate here all that Leonardo depicted and discussed in Codex Madrid I relating to the constructive elements of machinery. I shall have to limit myself to showing some of the most important cases.

A screw is an inclined plane wrapped around a cylinder. A wedge is also an inclined plane, but whereas an inclined plane per se is stationary, the wedge moves in order

152

to lift, split, or separate some material. In Leonardo's analytic mind these three simple machines are intimately related and mechanically equivalent. Magnificent diagrams illustrate the points he wants to make; only a few can be presented here.

The screw has an important place in Leonardo's mechanical studies, as indicated by the extent to which it is dealt with in his summary quoted above. The geometry of the screw is examined on many pages of Leonardo's works, and in Codex Madrid I as well as in other writings by Leonardo, we find a great variety of screws and their applications.

For special purposes screws can undergo various modifications. The form of the thread varies with the use to which the screw will be put. Leonardo knew V-shaped and square-threaded screws, as well as right- and left-handed screws. A favorite device of his was the combination of right- and left-handed screws on a single spindle in order to obtain special mechanical effects. Screws can also be compounded in order to augment quickly the distance of the elements connected with them. But Leonardo notes that "even if this motion is highly speculative and very fancy, it is nonetheless too intricate and difficult. It is therefore preferable to use screws having multiple threads." Such "fast" thread screws are well known and used today.

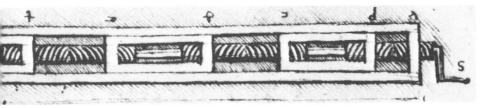

The effect of combining right- and left-handed screws can be compound through the use of multiple threads on a single shaft – as shown above in Codex Madrid I, folio 57 verso, and below in Codex Atlanticus, folio 379 verso-a. Known as "fast" threads, such screws are used in many modern mechanisms.

Folio 94 recto, Madrid I (left), gives geometric evidence of Leonardo's finding that a screw acts like a lever. Folio 175 verso (far left) demonstrates, in the sketch at top, the mechanical equivalence of four mechanisms – inclined plane, screw, block and tackle, and differential hoist.

The inverted screw is a screw in which the threads begin in the middle of its length, and departing from the middle, terminate at the opposite ends of the screw. Such a screw must have 2 nuts, since 2 different types of screws are actually being joined together here.

If you turn the inverted screw by both contrary and varied motions, their nuts will also have contrary and varied motions between them.

If in turning the inverted screw, you keep one of its nuts steady, the motion of the other nut will double that of the first one in both length and effort.

Every moving force exerts more strain on the point upon which it rests than on the thing which is moved.

Scores of Leonardo's mechanical sketches depict the screw in its many varieties and applications. At left, in Codex Madrid I, folio 58 recto, he demonstrates the mechanical effects that can be obtained by combining right- and left-handed threads on a single shaft. Turning the lever in the top diagram tightens or loosens both nuts at the same time, thus doubling the efficiency of the effort.

In Leonardo's papers we also find the drawing and the neat description of the first differential screw, that is, a spindle provided with two screw threads of different pitch. Leonardo unfortunately does not tell us about the use of this device. The invention of the differential screw, so important for the construction of scientific instruments, has been attributed to Hunter (1781).

The thoroughness of Leonardo's method is revealed by his concern to examine not only the shape but also the work or function of the mechanical elements investigated. He seems to apply here the same kind of reasoning that led him to the study of the human body, both as anatomist and as physiologist. Or was it the other way around?

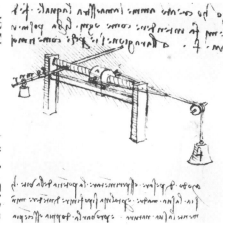

To test the power of screws, Leonardo developed in Codex Madrid I the five devices shown above, which indicate the use of weights to measure performance. From left: folios 121 recto, 121 verso (two illustrations from this folio), 4 verso, and 81 verso.

History's first record of a differential screw – a shaft equipped with two screw threads of different pitch – appears in Codex Madrid I, folio 33 verso (left). To the right is a modern diagram of the device, which has been attributed to Hunter in 1781 and which is essential in scientific instruments such as astronomical telescopes.

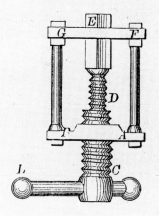

Screws must be tested before using them in order to establish the correctness of their shape and the limits of their performance and resistance. In Codex Madrid I we find explanations of the theory of screw action, and screw-testing machines are presented. But it is useless to discuss screws unless precise tools and processes for their making have been developed. A handy screw-cutting instrument is described

in our codex, but more striking is the well-known one presented in Manuscript B. This screw cutter is a true forerunner of modern machine-shop practices, with its interchangeable operating wheels and double screw rods, which ensure stability and precision.

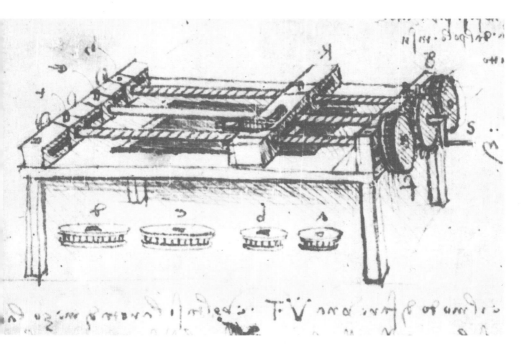

Up to this point screws have been discussed as independent entities. In combination with other machine elements, screws can be used for the most diverse functions. Leonardo projected hundreds of instruments in which the screw is the principal element. As a general rule he advises, "Dealing with heavy weights, do not commit yourself to iron teeth, because one of the teeth may easily break off; you will use therefore the screw, where one tooth is bound to the other." But a screw "shall be employed pulling, not thrusting, because thrusting bends the shaft of the screw, while pulling straightens the bent one."[26]

Worm gears, that is, the combination of screw and toothed wheel, . . . are among the favorite mechanisms of the machine constructor for two main reasons: their motion is irreversible and they ensure a high mechanical advantage. On one page

Leonardo also drew and described precision means for machining screws. The screw-cutting device below is in Codex Madrid I, folio 91 verso. A more elegant model (opposite page) in Manuscript B, folio 70 verso, is a forerunner of modern machine-shop practices.

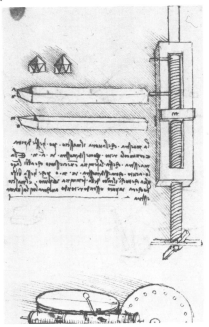

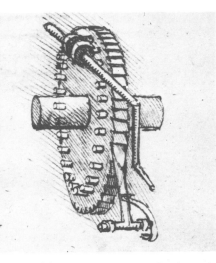

On folio 17 verso, Leonardo drew the traditional type of worm gear and noted its drawback: "When you make a screw that engages only a single tooth on the wheel, it will be necessary to add a pawl in order to avoid the reversal of the wheel's motion should that tooth break." Such a screw, he says, "could cause great damage and destruction."

of Codex Madrid I Leonardo considers two kinds of worm gear. One follows the traditional design. However, Leonardo observes, "When you make a screw that engages only a single tooth on the wheel, it will be necessary to add a pawl in order to avoid the reversal of the wheel's motion should that tooth break." The other design is Leonardo's own idea of how a worm gear should be constructed. He explains, "This lifting device has an endless screw which engages many teeth on the wheel. For this reason the device is very reliable. Endless screws that engage only one of the teeth on the working wheel could cause great damage and destruction if the tooth breaks." This device depicted by Leonardo is well known to modern machine constructors. It is called a Hindley worm gear, named after the English clockmaker Henry Hindley, who was very proud of having invented it. He died in 1770.

Leonardo's worm gear (below), in Codex Madrid I, folio 17 verso, is the same as the Hindley worm gear (right), named for the 18th-century English clockmaker Henry Hindley, who got the credit for inventing it.

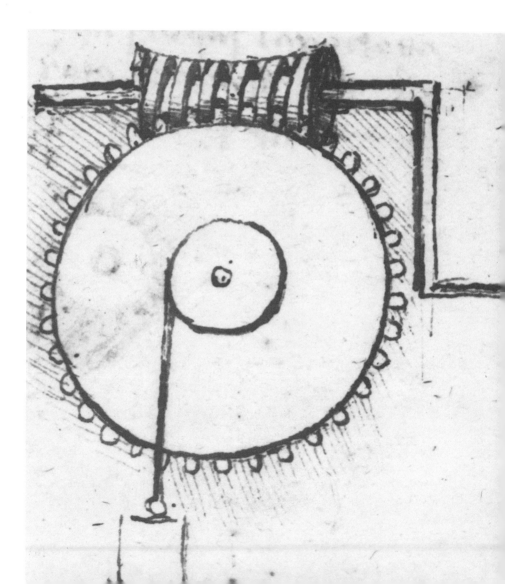

Leonardo worked with a simple efficient mechanism familiar to machine builders today as a worm gear (photo below). It meshes a gear or toothed wheel with a worm screw, which because of its infinitely spiraling thread Leonardo called an "endless screw." Engineers apply the worm gear with its low turning speed and relatively high amplification of power to rack-railways.

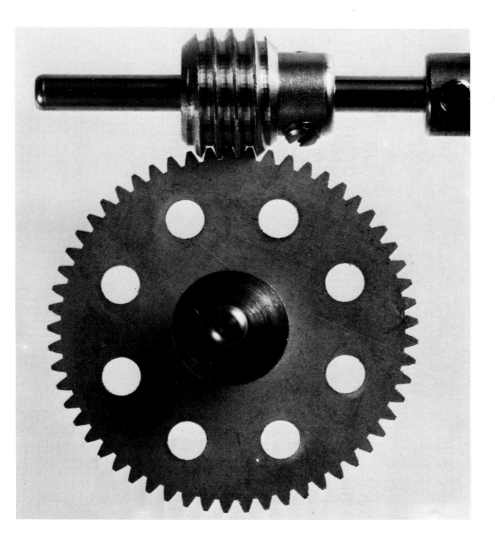

In another original combination of screws and gears depicted in Codex Madrid I, two long screws are turned at the same speed by a single shaft provided with two identical worms. The shaft is turned by another worm connected to a hand crank. The device is a double screw-jack, of slow motion but enormous power.

Interesting examples of keys, in the sense of joining devices, are also provided in Codex Madrid I. The keying together of wooden pipes is demonstrated, and joints for the legs of pieces of furniture and the pivots of compasses are illustrated.

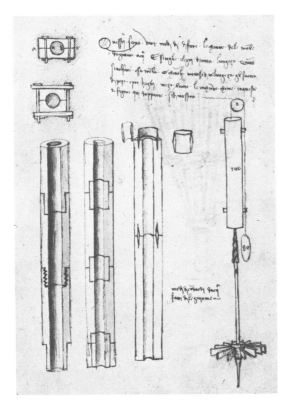

Lessons in joinery are provided by Leonardo in Codex Madrid I. Folio 25 verso (left) illustrates a method of making water pipes from logs with the boring device at far right. If the logs are not long enough, he suggests constructing the pipes in foot-long sections. The sections are then keyed together by metal couplings buried in each joint.

In Leonardo's time and later, the bearings in which shafts and pivots rotated were generally little more than holes in the wooden or metallic frame of the machine. Efforts at lubrication were made by trying to pour oil or spread tallow between the moving surfaces in contact. Searching through the Spanish archives in the ancient town of Simancas for records of the forgotten waterworks constructed by Juanelo

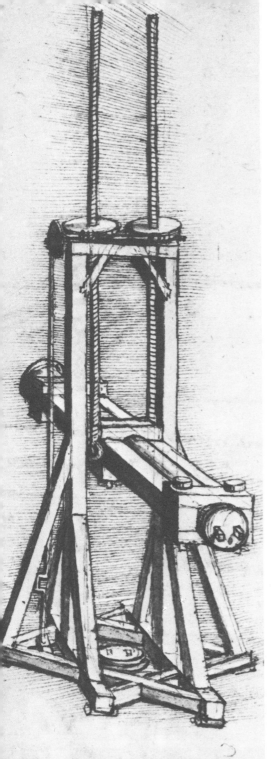

Through variations on the worm-gear idea, Leonardo could design machines to multiply manyfold the lifting power of men. This double screw-jack is powered by the crank at left. One worm gear turns the horizontal shaft, which is equipped with two identical worm gears. These turn the two long vertical screws at the same speed. Slow but powerful, the device probably was intended for lifting into place such tall heavy objects as stone columns or even cannon barrels.

165

Leonardo also offered tips, in Codex Madrid I, folio 62 recto, for joining the pivots of compasses and the legs on furniture – at left and above. "This is a method for inserting one piece of wood into another," he writes, "and you shall never be able to pull it from its cavity." He adds a practical note: "It could be used for the legs of a bench."

Turriano in Toledo, which were in use from about 1569 to 1620, I found only two items of heavy expense for maintenance: tallow for lubrication and charcoal for the forges that had to be operated constantly to repair the machine elements that broke down or wore out.

Leonardo investigated and described the wear on axles and bearings, searching for its cause and suggesting means for its relief. In Codex Madrid I he shows that the amount of wear in a bearing supporting a horizontal axle is related to the load and that the direction of the wear is not necessarily vertically downwards, but follows the main vector or direction of the load.

On another page of the codex the wear of axles and bearings is reexamined in relation to the length and thickness of the shafts. The central sketch represents two horizontal spindles, one of them provided with a modern-looking self-oiling device. But Leonardo observes that such a system would not work well because filings from the wear, dust, and oil would soon clog the outlets.

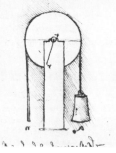
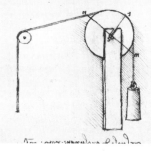

Leonardo's investigations of friction and the use of bearings to ease it are of special interest to modern engineers. Above, in Codex Madrid I, folio 132 verso, he studies the direction of the wear on axles and bearings and concludes that it follows the direction of the load.

Folio 118 recto (above) examines wear in relation to the length and thickness of axles. The sketch at right equips one of the shafts with a modern-looking self-oiling device, but Leonardo rejects this because it would soon become clogged with grit.

An interesting demonstration is given in the lower drawing: the result of reciprocal wear of shaft and bearing in a horizontal axle. The shaft is slowly consumed by the bearing but so is the bearing itself, leading to the tapering groove depicted. The problem of the shape of axles resulting from wear is discussed on many pages. Realizing that lubrication alone could not prevent the rapid wear of an axle and its bearing, Leonardo began to explore new ways, such as the use of materials that would minimize friction and the development of designs that would compensate the inevitable wear. In the same Madrid Codex we find a surprisingly modern concept along these lines. Leonardo devised a bearing in the form of a two-piece block that would prevent an axle from jumping out of the bearing "in spite of any strain." As he described this system, the cheeks of the block, in which the axle rotated, would be made of a smooth "mirror metal" consisting of "three parts of copper and seven of tin melted together." This "mother," as Leonardo called it, would be closed at the top with a wedge for tightening or with a cover that could be adjusted by a screw. Thus the cheeks, or bushings, could be tightened around the axle as wear progressed. We have here, in Leonardo's detailed description, the first suggestion of a bearing block, with split, adjustable bushing of antifriction metal, almost two centuries before Robert Hooke proposed the use of such metal to the Royal Society of London and more than two centuries before the split-bushing idea was embodied in hardware.[27]

Leonardo went on to study the possibilities of minimizing friction by means of rolling elements, as his experiments had shown that rolling friction was always

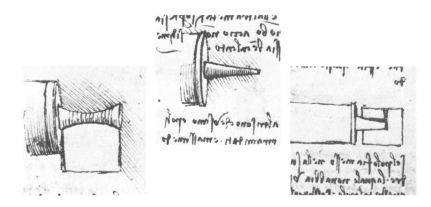

Folio 119 recto (above) presents the problem of shapes of axles resulting from wear. At left are shown an axle and bearing shaped to prevent lateral motion as the axle wears. At right are cone-shaped axles and a bearing for taking up the wear.

On folio 100 verso (below) Leonardo arrived at a modern concept for minimizing friction. He suggests a two-piece bearing block with bushings made of an alloy of copper and tin – a smooth "mirror metal." As the axle wears down, the bushing can be tightened on the axle – at left by means of a wedge, at right by a thumbscrew.

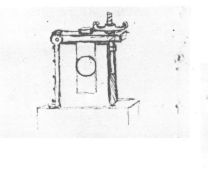

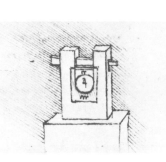

preferable to sliding friction. The use of rollers and balls to facilitate movement in machines is by no means original to Leonardo. Such devices had been employed in machines as early as the ancient Greek period. As next earliest, credit must go to the bearings of the rotating platforms of the Roman ship built between A.D. 44 and 54 that was recovered from Lake Nemi, near Rome.[28] Those were not true ball bearings, however, because the balls did not rotate freely in their holds: each ball was prolonged at two poles into short shafts or trunnions, kept in place by clamps.

Disc bearings – that is, axles rotating between two crossed or almost touching discs – must have been known before Leonardo. He depicts such devices in his early Manuscript B (of about 1489)[29] and in other manuscripts. They also appear in Georgius Agricola's *De re metallica*,[30] showing that they were well known in the praxis of the first half of the 16th century. However, in an interesting note on folio 12 verso of Codex Madrid I, beneath the drawing of a disc bearing, Leonardo notes, "Giulio says that he has seen two such wheels in Germany and that they became worn down at axle *m*" (the spindle). Giulio was a German mechanic who entered the service of Leonardo in 1493.[31] The note is important not only for dating the Madrid manuscript; it also proves that the inadequacy of disc bearings was a problem common to builders of machines.

Folio 12 verso of the Madrid Codex is a remarkable document. It shows how Leonardo's mind works, starting from what is known and experimenting with solutions that seem to him to be improvements on existing practices.

The problem to be discussed is the best possible arrangement for a horizontal bearing. In the first sketch at upper right Leonardo returns to the compound disc bearings that he has already rejected – in Manuscript B the same drawing is invalidated by a pen stroke and the word *falsa* added. At the upper center of the Madrid page the wear of a horizontal bearing is sketched again. Under the sketch are three studies on the disc bearing with the information given by Giulio. Then a new idea strikes Leonardo: instead of placing an axle *between* two rollers that inevitably exert a shearing action on the shaft, which in turn permanently forces them apart, why not try to place the axle *upon* a roller?

The answer is given in the scheme sketched to the right of the disc-bearing series. An unexpected difficulty immediately arises: as the axle turns, a lateral pressure is exerted, which cannot be taken up by a roller placed under the axle. So two additional rollers are added to the system in order to compensate lateral thrusts. The three-roller system is drawn beneath the sketch of the axle on one roller. Under the drawing, Leonardo proudly adds, "This is the best possible solution if the axle makes complete revolutions."

This is a good solution for a continuously revolving shaft. But what if the axle makes only partial to and fro revolutions, as in the case of a bell shaft? Evidently sectors could substitute for a complete roller. Leonardo first tries two inclined sectors, but finds that the shearing action has returned. The final solution appears in the two diagrams at the bottom of the page; the shaft is supported by a single sector, and the lateral thrust is taken up by two additional inclined sectors. Under this drawing, Leonardo declares, "This is the best solution to support an axle that does not make complete revolutions."

The presence of bell yokes in the drawings points to the main application Leonardo had in mind. The solution found needs, however, to be improved: the lateral segments can be made more efficient by placing them horizontally. This Leonardo does in other sketches that appear in the Codex Atlanticus – on folios 351 recto-a and 392 recto-b. All this would seem to be interesting play with kinematic problems, were it not that the same device appears more than 200 years later in Leupold's renowned *Theatrum Machinarum*,[32] where a bell support identical to Leonardo's is called "the oldest and most common system." Apparently, the first solution in Codex Madrid I was sketched around 1495; other solutions were elaborated by Leonardo later, becoming identical to the model described by Leupold.[33]

Roller bearings, wrote Leonardo, are "marvels of mechanical genius." With them he engineered the system shown here for supporting a bell with relatively little friction. Below, in Codex Madrid I, folio 12 verso, he sketched ordinary disc bearings – an axle rotating between two discs. But he knew the discs wore down the axle and already had rejected them in Manuscript B, folio 33 verso (bottom, left), striking a line through the sketch and writing falsa. On the same Madrid folio, 12 verso, he places the shaft holding the bell upon a single roller bearing – actually a cam-like sector – and adds two additional rollers to stop lateral thrusts (left and bottom right).

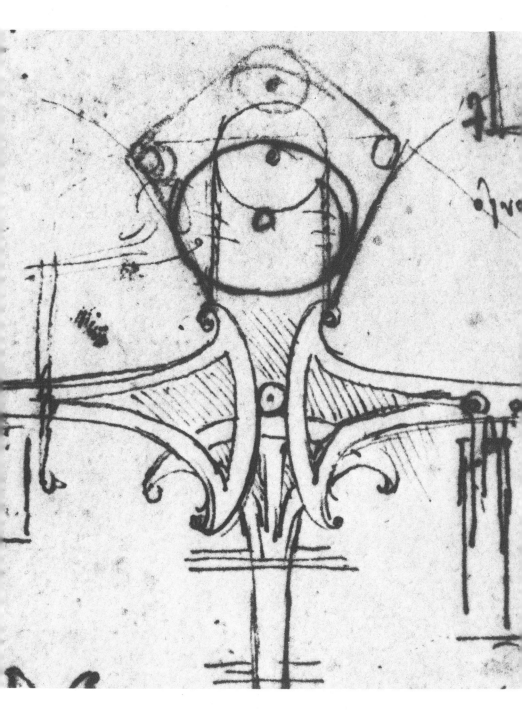

Leonardo's final solution (left) to the horizontal bearing arrangement problem in Codex Atlanticus, folio 392 recto-6, puts the side rollers at right angles to the vertical roller.

Although Leonardo's bell-support system using roller bearings was put to practical application in the **Mutte** bell at the Cathedral of Metz (above), precisely how the idea found its way to the cathedral is a mystery, as with so many applications of Leonardo's work. The cathedral's original bell is believed to have been installed in 1381. It was not a success, and over the next two centuries several new bells were cast. The bell was recast for the final time in 1605. Leonardo's preliminary solution to the bell-support problem was drawn in Codex Madrid I about 1495. Then no trace of the idea appeared in the literature – not even in a 1540 treatise by Biringuccio, who devoted four chapters to bells – until 1724, when it suddenly showed up in Jacob Leupold's book, which calls it "the oldest and most common system" but says nothing of Leonardo's role. In 1845 J. V. Poncelet's treatise made clear the same method was used at Metz – again without reference to its apparent inventor, Leonardo.

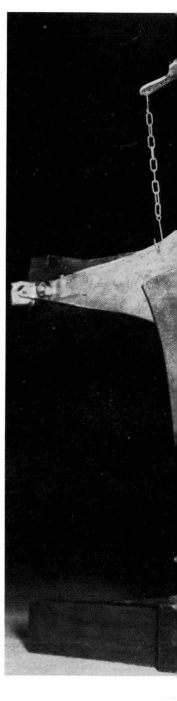

More than 200 years after Leonardo made
the sketches for the bell support shown on
the preceding pages, an identical system
appeared in Jacob Leupold's Theatrum
Machinarum Generale *(above)*. Then,
another century later, J. V. Poncelet in his
Traité de Mécanique Industrielle *described
the method used in supporting the* Mutte
*bell in the Cathedral of Metz (below) – an
exact copy of Leonardo's solution. A work-
ing model (photo, right) based on Leo-
nardo's drawings was commissioned by the
author of this chapter and carried out by
Sinibaldo Parrini of Florence.*

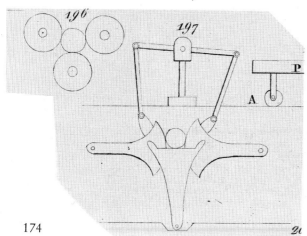

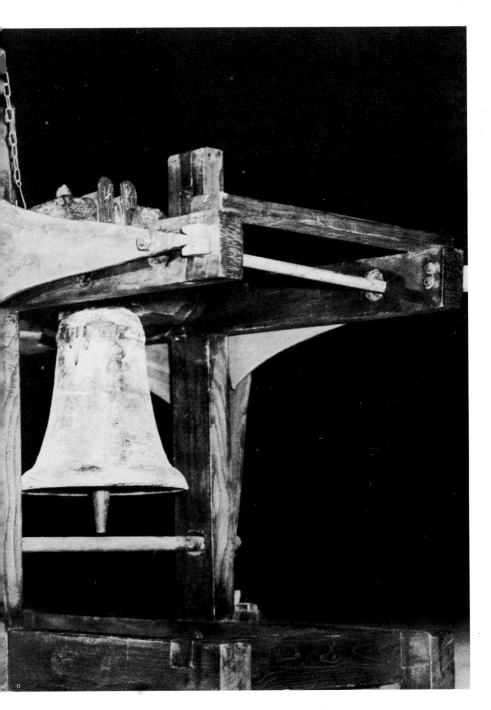

Was this system invented by Leonardo? Apparently it was. It was unknown to him a few years before Codex Madrid I, when dealing with the same problem in Manuscript B. It was unknown to Francesco di Giorgio Martini, who was well acquainted with bells and their making. In a treatise which precedes these writings of Leonardo, Francesco discusses several solutions, none of them good because the center of gravity of the bell is irrationally placed. He seems to know about axles resting *between* rollers, but not *on* rollers. But our surprise increases when looking at the solutions proposed by Biringuccio in 1540 in his treatise dealing with metallurgy called *Pirotechnia*.[34] He was an expert founder of bells, and he dedicated four chapters of his book to the subject; but when the problem of their hanging arises, he finds no better solution than to copy Francesco di Giorgio. The figures are redrawn, but the source is evident.

So when do these solutions of Leonardo enter in the stream of technological developments, solutions that according to Leupold were "most common" in the first half of the 18th century?

Leupold does not tell us about the origin of this interesting device. But about 120 years after him, when better ways of avoiding friction were beginning timidly to be suggested, the great French engineer J. V. Poncelet, in his *Traité de mécanique industrielle* published at Liège in 1845, tells us how the problem was resolved in the case of the famous *Mutte* bell of the Cathedral of Metz, which has an exact copy of Leonardo's bell supports. A sector sustains the axle, which, instead of sliding, rolls on it, while two lateral sectors take up side displacements. To sustain turning axles, Poncelet proposed to have them surrounded by three complete rollers – another correspondence to Leonardo's proposal.[35]

The original *Mutte* bell is supposed to have been installed in the Cathedral of Metz in 1381. But this bell was not successful. In the same year work was begun again; the new bell lasted for a very short time. In 1427 a fresh attempt was made, but with no success, for on March 21, 1442, the bell cracked and it was decided to recast it. The work of taking it down caused two deaths and a number of injuries. In 1443 a new bell was completed, but it did not last long; in 1459 it was out of use. A new bell was cast in 1479, this time by expert founders, and installed in 1482. It lasted almost a century – until 1569. The *Mutte* was recast for the last time in 1605.[36] The fact that it has lasted since then indicates that better techniques had by then been developed.

But how can the same problem be resolved when the rolling axle moves vertically

instead of horizontally? Jacks operated by the turning of a screw for lifting heavy loads were in wide use in Leonardo's day; their usefulness was limited, however, because under strong pressure severe friction developed between the turning nut and the plate on which it weighed.

So Leonardo decided to introduce what we today call a thrust bearing. In Codex Madrid I the use of ball and roller bearings is presented, and there is a sketch which can be compared with a modern ball thrust bearing. Leonardo's extremely interesting text shows his awareness of the problems of friction in roller bearings.

An array of bearing shapes intended to support a vertical axle is presented on folio 101 verso (above and p. 178). In the sketch above a conical-shaped pivot rests in a nest of three ball bearings – a concept that had to be reinvented during the 1920s for blind-flying instrumentation on airplanes.

The idea is further developed on other pages of Codex Madrid I. On one page we can admire a surprising array of roller and ball bearings sustaining the thrust of a vertical axle. Commenting on the ball bearing Leonardo declares that "three balls under the spindle are better than four, because three balls are of necessity certainly always touched, while by the use of four there would be the danger that one of them is left untouched."

Leonardo is in favor of design *a,* incorporating three conical rollers supporting a pivot provided with a conical head of the same size and shape as the rollers. He says, "This way we shall have three equal cones that are identical to the cone of the spindle, and by each turn of the spindle, the supporting cones will have each made a complete revolution."

Leonardo introduced what we today call the thrust bearing. The sketches to the left illustrate bearing shapes intended to sustain the thrust of a vertical axle. The accompanying text clearly demonstrates his awareness of the problems of friction in roller bearings.

A precursor of today's thrust bearing appears in a sketch of a screw-jack (right) in Madrid I, folio 26 recto. In the upper left-hand corner of the folio Leonardo noted the similarity of ball and roller bearings. Leonardo uses ball bearings to ease friction between the turning nut and the plate of his jack – much as in the diagram of a modern thrust bearing shown above.

I am indebted to Preston Bassett, former president of the Sperry Gyroscope Company, and to Bern Dibner, founder of the Burndy Library of Norwalk, Connecticut, for permission to quote from a letter that Dr. Bassett wrote to Dr. Dibner on March 8, 1967, after seeing this Leonardo drawing reproduced in *Life*. "I must tell you my greatest shock in looking over the Da Vinci sketches was the balls nested around a conical pivot. When we were developing our blind-flying gyro instruments in the 1920's we had the problem of designing a ball-bearing that

would have absolutely no end play. We thought we had an innovation with our conical pivot ball bearing, but it is a dead-ringer of Da Vinci's sketch!"

Leonardo very soon recognized that a bearing would work satisfactorily only if the balls or rollers did not touch each other during operation. In Codex Madrid I a ring-shaped race for a ball bearing is devised, to eliminate the friction that would result if the individual balls in a bearing came in contact with one another. The

Leonardo drawing has become quite well known to today's public thanks to its use for publicity by a large American pen company.

Since Leonardo's principal language was graphic representation, his experimental

A measure of Leonardo's mechanical prescience is the similarity of the two illustrations shown here. Above is a photograph of an up-to-date set of ball bearings. At right, sketched and lettered in Leonardo's clear hand, is his ball-bearing race, inscribed on folio 20 verso of Codex Madrid I nearly 500 years ago. When Leonardo began his studies of bearings and friction, the state of technology was primitive. Crude roller and ball bearings had been used by the ancient Greeks, and the remains of a Roman ship indicate a type of static ball bearing was employed for rotating platforms shortly after Christ's birth. In his studies Leonardo arrived at several general principles of friction and conceived true ball and roller bearings that anticipated in detail the components so essential to modern mechanisms, from roller skates to the automobile. He recognized that "if balls or rollers touch each other in their motion, they will make the movement more difficult than if there were no contact between them." His solution was to place the bearings in the ring-shaped race shown here so they could rotate freely. The ball race did not appear again until it was reinvented in 1772 and tested on road vehicles.

investigations of friction can be best understood by examining his drawings. One shows a bank device for the measurement of sliding friction (identical with a friction bank that Charles Augustin de Coulomb devised 300 years later) and also illustrates an apparatus for measuring rolling friction. Other drawings picture experiments in which Leonardo measured frictional resistance on an inclined plane, looked into the question of whether or not frictional resistance depended on the area of contact between surfaces, and examined how the ease of rolling motion of a shaft might be affected by the shaft's diameter.

From his measurements Leonardo derived several general principles, namely that frictional resistance differs according to the nature of the surfaces in contact, that it depends on the degree of smoothness of those surfaces, that it is independent of the area of the surfaces in contact, that it increases in direct proportion to the load, and that it can be reduced by interposing rollers or a lubricating fluid between the sliding surfaces. These laws sound obvious today, but one should bear in mind that Leonardo demonstrated them quantitatively two centuries before scientists initiated the modern study of friction and three centuries before the study of this subject was elaborated by Coulomb.

For better or for worse, our times are dominated by technology. So were all times past, even if this appears less evident to us today. And there is no reason to suppose that the future will be different unless we are willing to reduce drastically our numbers and accept a civilization based on serfdom, or reduce humanity to a condition of general misery. Technology, however, should be the servant, not the master of man; its faults can be remedied, its values enhanced. One thinks, in this context, of a world where all the money and effort used up by armaments are dedicated to solving the ecological problems forced upon us by political and economic mismanagement.

This ambivalence in the impact of technology on human affairs was keenly understood by Leonardo, in an epoch when the ecological problems that afflict us today were just beginning to take shape.

Nothing characterizes better Leonardo's inner feelings before these problems than some of his "prophecies," a literary genre that seems original to him. The "prophecies" are in fact riddles that were recited at court gatherings or in gay companies, and were to be solved by the participants. In them, under the subtle veil of play, Leonardo succeeded not only in pointing out the vices and abuses of his time . . . without incurring disgrace, but also in expressing his despair about the wickedness of humanity in general.

An appropriate example is this "prophecy" found in the Codex Atlanticus: "There shall come forth out of dark and gloomy caves that which shall put the whole human race into great afflictions, dangers, and deaths. To many of its followers, after great troubles, it will offer delight; but whoever is not its supporter shall perish in want and misery. This shall commit an infinity of treacheries, prompting wretched men to assassinations, larcenies, and enslavement; this shall hold its own followers in suspicion, this shall deprive free cities of their liberty, this shall take away the lives of many people, this shall make men afflict upon each other many kinds of frauds, deceits, and treacheries. O monstrous animal, how much better were it for men that thou shouldst go back to hell! Because of this the great forests will be deprived of their trees and an infinity of animals will lose their lives."

The solution of the riddle is given in the title: "Of metals."[37]

Nearby there is another even more ominous "prophecy" entitled "Cruelty of man." It is a remarkable document in which Leonardo makes mankind responsible

for the evils of society and for the destruction of nature's gifts and beauty: "Creatures shall be seen upon the earth who will always be fighting one with another, with very great losses and frequent deaths on either side. These shall set no bounds to their malice; by their fierce limbs a great number of the trees in the immense forests of the world shall be laid level with the ground; and when they have crammed themselves with food it shall gratify their desire to deal out death, affliction, labors, terrors, and banishment to every living thing. And by reason of their boundless pride they shall wish to rise towards heaven, but the excessive weight of their limbs shall hold them down. There shall be nothing remaining on the earth or under the earth or in the waters that shall not be pursued, carried away, or destroyed, and that which is in one country shall be taken away to another; and their own bodies shall be made the tomb and the means of transit of all the living bodies which they have slain. O Earth! what delays thee to open and hurl them headlong into the deep fissures of thy huge abysses and caverns, and no longer to display in the sight of heaven so savage and ruthless a monster?"

All the animals languish, filling the air with lamentations. The woods fall in ruin. The mountains are torn open, in order to carry away the metals which are produced there. But how can I speak of anything more wicked than (the actions) of those who raise hymns of praise to heaven for those who with greater zeal have injured their country and the human race?

ATLANTICUS 382v-a

In the realm of human affairs, as in technology, Leonardo proved himself a prophet of modern times. No other man of the Renaissance seemed to embody so dramatically or to see so clearly as Leonardo the contradictions of the human condition. In art he was a servant of beauty, in war a servant of the bestiality he deplored. He was the creator of the delicate trees shown here, Windsor Collection No. 12431 recto, and master of the embryonic technology that in its abuse would some day threaten their beauty. Leonardo poured out his own concern in a series of written "prophecies" – riddles that, under their playful surface, revealed his despair about mankind. A prophet of the modern ecological movement, he foresaw a time when "the great forests will be deprived of their trees" and when men would "deal out death, affliction, labors, terrors, and banishment to every living thing."

FOOTNOTES

THE MILITARY ARCHITECT

1 Codex Atlanticus, fol. 234v-b.
2 Windsor 12686r.
3 Manuscript L, fol. 80v.
4 Ibid., fols. 81v and 81r.
5 Ibid., fol. 82v, 83r, 83v, 84r.
6 Codex Atlanticus, fol. 130r-c.
7 Manuscript L., fol. 6 v.
8 For example, fol. 46r.
9 Codex Madrid 1, fols. 110v and 111r.
10 Codex Atlanticus, fols. 289 and 398r.
11 Codex Madrid II, fol. 25r.
12 Ibid., fol. 24v.
13 Ibid., fol. 125r.
14 Ibid., fols. 1v, 6r, 10r, 37v.
15 Ibid., fols. 9r, 15r, 21v, 24r, 25r, 32r (?), 36v, 38r, 38v, 62v bis 64v.
16 Ibid., fols. 9r, 10r.
17 Ibid., fol. 32v.
18 Ibid., fol. 38r.

MACHINES AND WEAPONRY

1 Codex on the Flight of Birds, fol. 3r.
2 Theodor Beck in his *Beiträge zur Geschichte des Maschinenbaues* (Berlin, 1899) lists over 400 machines and devices. The Madrid Codices added hundreds more.
3 Cf. L. Reti, "The Double-acting Principle in East and West," *Technology of Culture*, vol. II, pp. 178-200, 1970.
4 Leonardo's intent is quite clear, but the mechanism as he sketched it is not fully functional.
5 F. M. Feldhaus, *Leonardo der Techniker und Erfinder* (Jena, 1913).
6 Chief engineer to the Duke of Urbino. He served with Leonardo on commissions to erect the *tiburio*, or central tower, of the Cathedral of Milan and to construct a cathedral at Pavia. A treatise on civil and military architecture, that he wrote and illustrated himself, now in the Laurenziana in

Florence, has manuscript notes by Leonardo.
7 After the British artillery officer Henry Shrapnel, who lived from 1761 to 1842.
8 On fols. 51r, 53r, 54v, 59r, 59v, 131r, and 143r.
9 A. R. Hall, *Ballistics in the Seventeenth Century* (London, 1952), pp. 42, 83.
10 The term "accidental motion" is used in contradistinction to "natural motion."
11 See A. C. Crombie, *Augustine to Galileo* (London, 1952), pp. 254, 280, and Hall, op. cit. L. Reti deals with Leonardo's ballistics in "Il moto dei projetti e del pendolo secondo Leonardo e Galileo," *Le Macchine*, Milan, December 1968.
12 Tartaglia, *La nova scientia* (Venice, 1537).
13 Tartaglia, *Quesiti et inventioni diverse* (Venice, 1546).
14 Manuscript E, fol. 70v.
15 Galileo Galilei, *Dialogo...sopra i due massimi sistemi del mondo...*(Florence, 1632), in *Opere*, vol. VII, pp. 47, 177 ff.
16 E. Torricelli, *De motu gravium et proiectorum*, in *Opere* (Faenza, 1919), p. 157).
17 Ibid., p. 188
18 See H. L. Peterson, *Pageant of the Gun* (New York, 1967), p. 18, and T. Lenk, *The Flintlock* (New York, 1965), p. 13, where Lenk says. "Most recent research accepts the Leonardo drawings as the earliest record of the wheel-lock and certain Italian combined crossbows and wheel-lock guns in the Palazzo Ducale, Venice, as the earliest surviving examples of the construction". This note appeared two years before the re-exposure of the Madrid Codices.
19 Codex Atlanticus, fols. 56v-b, 217r-a, 353r-c.
20 Cf. L. Reti, "Il Mistero dell'architronito," *Raccolta Vinciana*, fasc. XIX, pp. 171–183, 1962.
21 Codex Madrid 1, fols. 26r,

84v.
22 Codex Atlanticus, fol. 198v.

THE ENGINEER

1 Gerolamo Calvi, *Notizie dei principali professori di belle arti che fiorirono in Milano durante il governo de'Visconti e degli Sforza, part III: Leonardo da Vinci* (Milan, 1869).
2 Luca Beltrami, *Documenti e memorie riguardanti la vita e le opere di Leonardo da Vinci* (Milan, 1919), no. 108. See also no. 107.
3 Manuscript L., fol. 66r.
4 J. P. Richter, *The Literary Works of Leonardo da Vinci*. 2d ed. (London, 1939), vol. II, p. 215, no. 1109).
5 *Le Vite de'piu eccellenti architetti, pittori et scultori* (1st ed. Florence, 1550; 2d ed. 1568). English translation by A. B. Hinds, edited with an introduction by William Gaunt (London: Everyman's Library, 1927; last reprint 1963), Giorgio Vasari, vol. 4, p. 122.
6 Franz Babinger, "Vier Bauvorschläge Leonardo da Vinci's an Sultan Bajezid II. (1502/3) mit einem Beitrag von Ludwig H. Heydenreich," *Nachrichten der Akad, der Wissensch., in Göttingen*, Philologisch – Hist, Klasse, Jahrg. 1952, no. 1, pp. 1–20.
7 Manuscript L., fols. 34v, 35r, 35v, 36r.
8 Ibid., fol. 25v.
9 In *Le Vite de'piu eccellenti architetti, pittori et scultori* (1st ed. Florence, 1550; 2d ed. 1568). English translation by A. B. Hinds, edited with an introduction by William Gaunt (London: Everyman's Library, 1927; last reprint, 1963), vol. 2, pp. 156–168. In the following excerpts Hinds's generally excellent translation has been slightly modified.
10 The memoirs, part of Codex H227 inf. of the Biblioteca Ambrosiana of Milan, have

been transcribed by Luigi Gramatica as *Le Memorie su Leonardo da Vinci di Don Ambrogio Mazenta (Milan; Alfieri & Lacroix, 1919).*

[11] Leo Olschki, *The Genius of Italy* (London, Gollancz, 1950), p. 308.

[12] Translated from "Leonardo da Vinci et la technique de son temps," in *Léonard de Vinci, & l'expérience scientifique au seizième siècle* (Paris: Centre National de la Recherche Scientifique – Presses Universitaries, 1952), p. 146.

[13] Joseph Needham, *Science and Civilisation in China*, vol. IV: 2 (London: Cambridge, 1965), p. 383: "When Leonardo faces the problem of interconversion in the late 15th century, nearly two hundred years after Wang Chen, he shows, as Gille has acutely pointed out, a most curious disinclination to use the eccentric (or crank), connecting-rod and piston-rod combination. In fact he does so only for a mechanical saw. In order to avoid it he has recourse time after time to the most complicated and improbable devices."

[14] Fol. 86r.

[15] H. W. Dickinson, *James Watt* (London: Cambridge, 1936), p. 124.

[16] Franz Reuleaux, *The Kinematics of Machinery*, new ed., with an introduction by Eugene Ferguson (New York: Dover, 1963), p. 9. 1st German ed. 1875; English translation by A. B. W. Kennedy 1876.

[17] See Theodor Beck, *Beiträge zur Geschichte des Maschinenbaues* (Berlin, 1899), and Abbot Payson Usher, *A History of Mechanical Invention*, rev. ed. (Cambridge: Harvard, 1954).

[18] Reuleaux, op. cit., p. 437.

[19] Ibid., p. 580.

[20] Codex Madrid 1, fol. 82r.

[21] Codex Atlanticus, fol. 155v-b.

[22] Leonardo da Vinci, 1 Libri di meccanica, nella recostruzione ordinata di Arturo Uccelli (Milan: Hoepli, 1940).

[23] Codex Madrid 1, fol. 96v.

[24] Codex Atlanticus, fol. 164r-a.

[25] Codex Madrid 1, fol. 97v.

[26] Codex Atlanticus, fol. 207v-b.

[27] Charles Plumier, *L'Art de tourner* (Paris, 1701).

[28] Guido Ucelli, *Le Navi di Nemi* (Rome: Libr. dello Stato, 1955), pp. 191–195.

[29] Manuscript B, fol. 33v.

[30] Georgius Agricola, *De re metallica*, translated from the first Latin ed. of 1556 by H. H. Hoover and L. H. Hoover (London, 1912), p. 173.

[31] Codex Forster III, fol. 89v.

[32] Jacob Leupold, *Theatrum Machinarum Generale* (Leipzig: C. Zuntel, 1724).

[33] I had a reconstruction made according to Leonardo's drawings on Codex Atlanticus fol. 35 Ir-a, dated probably around 1500. The work was carried out by •Dr. Sinibaldo Parrini, the well-known scientific instrument rebuilder of Florence, using a 14th-century bell. The result could not have been more satisfactory.

[34] English translation by Maria Teach Gnudi and Cyril Stanley Smith.

[35] I went to Metz to see the bell arrangement, but I was not allowed to go up to the tower because of the dangers. Dr. Ludolf von Mackensen of·the Deutsches Museum in Munich was more fortunate, and I am very grateful to him for the helpful photographs he was able to take.

[36] Marcel Aubert, *La Cathédrale de Metz* (Paris: Picard, 1931), pp. 251–263.

[37] Codex Atlanticus, fol. 370r, datable around 1495.

NOTE: Phaidon Press Limited, London, has kindly given permission to reprint the various excerpts of translations from Jean Paul Richter, *The Literary Works of Leonardo da Vinci*, 2d ed. (London, 1939).

190

191